Visions of the Heavenly Sphere

A STUDY IN SHAKER RELIGIOUS ART

MAJOR BOOKS BY
EDWARD DEMING ANDREWS

The community industries of the Shakers. Albany:
The University of the State of New York,
1932.

*The gift to be simple; songs, dances and rituals of
the American Shakers.* New York: J. J. Augustin,
1940. Reprinted, New York: Dover Publica-
tions, 1962.

*The people called Shakers; a search for the perfect
society.* New York: Oxford University Press,
1954. Enl. ed., including bibliographical in-
formation on more than 300 text references,
New York: Dover Publications, 1963.

Religion in wood; a book of Shaker furniture.
With Faith Andrews. Bloomington: Indiana
University Press, 1966.

*Shaker furniture; the craftsmanship of an Ameri-
can communal sect.* With Faith Andrews. New
Haven: Yale University Press, 1937. Re-
printed, New York: Dover Publications,
1950.

The Shaker order of Christmas. With Faith An-
drews. New York: Oxford University Press,
1954.

EDWARD DEMING ANDREWS AND FAITH ANDREWS

Visions of the Heavenly Sphere

A STUDY IN SHAKER RELIGIOUS ART

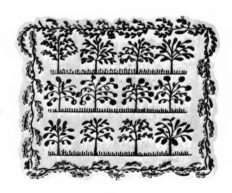

Published for The Henry Francis du Pont Winterthur Museum

The University Press of Virginia, Charlottesville

Contents

Illustrations

Foreword

BEFORE I went to college, I spent my summers with my grandparents in Columbia County, New York. To the west were the beautiful Catskills, on the other side of the Hudson. From the hill behind our house one could see, stretching away to the east, the equally beautiful Berkshires. Both ranges of mountains were the scene of much that is connected with the early arts of America.

It is the Berkshires that concern us here, the hills and mountains of eastern Columbia County and of western Massachusetts. The story of that country is less well known than that of Washington Irving's Catskills, but its ghosts are many, too: Edith Wharton motoring perilously over the difficult roads with her difficult house guest Henry James; Hawthorne at Tanglewood; great and gloomy Melville close to Great Barrington; and Bryant in Barrington itself. Most memories of the Berkshires are literary. The two great exceptions belong not only to the arts but also to the religion of early America. Although they differed in many ways, both were advocates of highly spiritual inner devotion. Both, too, in the eighteenth-century term were called religious "enthusiasts" in their own day.

The first of these enthusiasts was the intellectual giant from Northampton, Jonathan Edwards. Perhaps the most brilliant theologian of eighteenth-century America, Edwards moved to Stockbridge in Berkshire County from the Connecticut Valley. It was here that he set forth in his essay *The Nature of True Virtue* his explanation of the physical beauty which surrounded him and which strikes the visitor to the Berkshires even today:

And here by the way, I would further observe, probably it is with regard to this image or resemblance, which secondary beauty has of true spiritual beauty, that God has so constituted nature, that the presenting of this inferior beauty, especially in those kinds of it which have the greatest resemblance of the primary beauty, as the harmony of sound, and the beauties of nature, have a tendency to assist those whose hearts are under the influence of a truly virtuous temper, to dispose them to the exercises of divine love, and enliven in them a sense of spiritual beauty.

Later in the eighteenth century there came to the Columbia County side of the mountains the second of our enthusiasts — Ann Lee. She and her followers, the Shakers, brought to the Berkshires not profound and sophisticated theology but their own devotional literature. There they developed their own music and their monuments — but theirs, unlike Edwards', were visual.

The Berkshire Shakers were highly unorthodox Protestants. They were a celibate community, which, instead of a life in "the world," chose what theologians call the "contemplative life" in isolation among the beauties of nature. For them, the Berkshires were what the mountains of Italy and the loneliness of Yorkshire had been to the medieval monk. New Lebanon and Hancock were their Assisi and Fountains Abbey. True, not all of them chose such magnificent natural surroundings as the founder of their society, Mother Ann Lee, did in establishing New Lebanon. It was through her work that I first was made aware of the beauty of holiness, and of the holiness of beauty.

My grandparents and my aunt often took me to visit the Sisters of New Lebanon in the 1920's. From both Sister Sarah and her companions, and from the setting in which they lived, I learned to feel something of the spirit of Mother Ann and her first followers and the reason they had chosen the Berkshires as their home.

Like St. Francis and his early followers at Assisi, the Shakers were not intellectuals. However, those who are not saints need teachers to explain the holy life to them; they need to do more than feel. Luckily for me, the Berkshires also bore two persons who knew the Shakers, who devoted their lives to their study, and who have been able to help me and many others not only to love but also to understand, at least partly, the followers of Ann Lee.

As a boy I knew Edward Deming Andrews and his wife Faith only through their books. Nevertheless, they were my teachers even then. Both of them helped me understand the people of New Lebanon and Hancock. Both were born in nearby Pittsfield, where they devoted their lives to the study of its countryside and its truly beautiful people. Faith has asked me to say nothing about her own work, and I shall respect her modesty. But I, for my part, insist on pointing out that the Andrewses' vision has always been a deeply shared one. From their combined work I have learned to grasp not only the beauty of Shaker life and poetry but also that of their art.

The Mission House in Stockbridge is the only work of art in the Berkshires

associated with Jonathan Edwards. It is a lovely building, but he did not build it. He was almost purely a man of intellect and spirit and is not known to have produced any work of art. Fortunately for those of us who are more earth-bound, the Shakers were builders, furniture makers, and painters as well as great spirits. They put their love of holiness into their art. In his books Edward Andrews helps us to grasp the simplicity and purity not only of their lives but also of their buildings, their furniture, their clothes, their songs, their tools— even that least potentially religious of arts, their cooking.

Of all the art the Shakers produced, my favorite expression of their religion lies in their "spirit" paintings. Produced for the most part in the two decades before the Civil War, these pictures are unsophisticated but joyous. To me they are the heirs, not in form but in spirit and intent, to the medieval analogical and allegorical traditions preserved in part and developed in Edwards' great *A History of the Work of Redemption* (1774). They are also in spirit heirs of the mannerist literary pictures which art historians call "emblems" and "devices." They are pictorial symbols rather than copies of the seen world. They are, in the words of Perry Miller, "Images of Divine Things" and share the same pattern of intention which provides the skeleton for much of the poetry of Edward Taylor and Emily Dickinson as well as for Edwards' theology. Together with the works of these writers, the works of the Shakers are among the most touching expressions of that type of sixteenth-century and seventeenth-century European imagery which contemporary critics call "metaphysical."

This publication of the text of the book which Edward Andrews left behind him when he died in 1964, with the reproduction in color of many of the paintings he and Mrs. Andrews discovered, is a monument far more fitting than any stone creation could be to a man who had the taste, the learning, the wisdom, and the passion to preserve these precious fragments of our American aesthetic and religious heritage.

In return for all that the Berkshires have given me—including the Shakers and Edward and Faith Andrews—I regard it as a privilege to be asked to write this foreword to Ted's book.

I should like also to express here to Faith and her two children the gratitude of The Henry Francis du Pont Winterthur Museum and of the scholars of today and the future for their magnificent gift of the Edward Deming Andrews Memorial Shaker Collection. Mr. du Pont with great generosity has given us the Louise du Pont Crowninshield Research Building. We here at Winterthur will always treasure one of the great jewels it now contains. We will strive to pass on to our own pupils and heirs the vision of those who created it.

FRANK H. SOMMER III
Head of Libraries, The Henry Francis
du Pont Winterthur Museum

Winterthur, Delaware
January, 1969

An Acknowledgment

THIS book is dedicated to our many Shaker friends who opened their doors to reveal to us the existence of these drawings and stimulated us to the study of their meanings.

The research program involved in this project was made possible by a grant from the John Simon Guggenheim Memorial Foundation. Permission was given by Shaker Community, Inc., the recipient of fourteen drawings from the Andrews Collection, to obtain color reproductions for illustrative purposes.

To the staff of The Henry Francis du Pont Winterthur Museum, I wish to add my personal appreciation of their vision and understanding so necessary to the publication of this book—particularly to Mrs. Susan Terdiman, whose heroic work on the check list will put every Shaker scholar in her debt.

FAITH ANDREWS

Editorial Note

WHEN he died in 1964, Edward Deming Andrews left among his papers the manuscript of *Visions of the Heavenly Sphere*. At Mrs. Andrews' request, The Henry Francis du Pont Winterthur Museum has made no substantive changes in the manuscript in order to retain the integrity of Dr. Andrews' work and to make his discoveries and analyses available to the public as he left them. We believe that readers—both scholars and laymen—will find *Visions of the Heavenly Sphere* a valuable book and a fitting tribute to Edward Deming Andrews.

THE HENRY FRANCIS DU PONT
WINTERTHUR MUSEUM

Visions of the Heavenly Sphere

A STUDY IN SHAKER RELIGIOUS ART

Divine inspiration is a voice that speaks
from the spirit world to the soul of man.
If he has any interest beyond this world,
he should keep himself in a condition
to hear that voice, understand its
language and bow to its requirements.
—Shaker pamphlet, 1856

Introduction

I<small>N THE</small> retiring-room of the family dwelling of a New England Shaker community we were talking one evening in the 1930's with a sister of that religious order. When the conversation turned to the various modes by which a reticent sect expresses its inner spirit, she grew thoughtful and then said: "I have something to show you which I have kept secret since I was a child of eight. I want your opinion about it." She then opened a chest in a corner of the room and took out an illuminated scroll entitled "An Emblem of the Heavenly Sphere." As we looked at it, she was silent and watchful. Our reaction was one of delight and wonder; we did not know, after ten years' acquaintance with this secluded folk, that they ever attempted to depict the signs and objects of the spiritual world. Seeking an explanation for the document's nature and source, we learned that Sister Alice had rescued it from wastepaper consigned to an oven, had hidden it away, and as she grew older, had treasured it increasingly as a precious, if somewhat mysterious, expression of the Shaker soul. "My showing it to you was a test," she afterward declared. "If you had shown any evidence of levity in your response, I was prepared to keep it as mine alone. I would have known that 'the world' could not understand."

Such was our introduction to the inspirational drawings and paintings produced over a century ago by members of the Shaker sect, whose communal mode of life still exists after nearly two hundred years on American soil. Coexistent with the American republic, the United Society of Believers in Christ's Second Appearing at one time had eighteen branches distributed in five northeastern and three midwestern states. Its English-born founder, Mother Ann Lee, settled near Albany, New York, the year the Declaration of Independence was signed. Since then scores of books and pamphlets have been written about the Society's doctrines. However, outside the Society itself little has been known about its internal economy, its distinct craftsmanship, and the songs, dances, and rituals which constitute its peculiar worship. The purpose of the present

inquiry is in part to evoke—largely through the illustrations—the exalted spirit of a saintly people. The illustrations are also significant as examples of an original folk art, mature in quality but derived from an essentially primitive faith.

Most of the designs so far recorded had their origin either in the community of Hancock in western Massachusetts or at New Lebanon, the site of the central society, just over the Massachusetts boundary in New York state. Drawings were also produced, along with the characteristic songs, dances, and inspirational prose, in the sixteen other colonies in New England and New York, Kentucky, and Ohio; however, with a few exceptions, the documents have been lost or destroyed. The elders or ministry to whom nearly all the drawings were entrusted either disposed of them as exaggerated or obscure statements of spiritual experience or guarded them jealously from worldly misunderstanding and ridicule. In fact, few Believers who were alive during the period in question knew of the existence, to say nothing of the prevalence, of such forms of expression.

Shaker literature is almost totally silent on the subject. In certain respects, the pictorial compositions seem to contradict the philosophy of the sect, which held that anything excessive, decorative, or fanciful was useless and superfluous and, therefore, contrary to order. Indeed, much relating to the drawings is shrouded in mystery. It is clear, however, that under the surface of the disciplined, serene, and seemingly artless lives of the Shakers compelling forces were at work and became manifest in their mode of worship, particularly during the recurrent awakenings which marked the history of the movement.

The most remarkable of these revivals, called by the Shakers the "Era of the Manifestations," opened at the Watervliet, New York, colony in 1837 and lasted some ten years, with aftereffects noticeable for another decade or more. The waves of exaltation and mysticism which swept all branches of the society during this period produced a flood of songs, dances, and rituals.[1] The era was marked by a profusion of what the Shakers called "gifts"—the giving and receiving of diverse spiritual presents—which were the product of an afflatus so absorbing that no one at the time questioned the propriety of translating inspiration, or revelation, into terms of graphic imagery and colored symbols.

No claim is made that the drawings are representative of a school of native

[1] Edward D. Andrews, *The gift to be simple. Songs, dances and rituals of the American Shakers* (New York, 1940).

folk art. The period was too short for the artists to develop a tradition in form. Sometimes symbols have precise signification. Thus, apples usually represent love; cherries, hope; pears, faith; strawberries, union; roses, love or chastity. Chains are emblems of union and strength. Yet often an object may have diverse meanings. A rose may also signify patience, perseverance, charity, faith, or some other virtue. A colored ball may represent light, love, or comfort. Many precious and rare objects—golden chains, jeweled crowns, treasure chests, exotic blooms—serve to express the wonders of the "heavenly sphere." Biblical symbols are also used: the burning bush, the all-seeing eye, the bower of mulberry trees, the ship of safety, altars, crosses, and angels. Whatever the source, the drawings are remarkable in that they reveal the heart of a folk, who, freed for awhile to employ the medium, testified thereby to the simple beauty of their faith.

E.D.A.

I. *The Gift of Inspiration*

TO UNDERSTAND the motivating forces in Shaker religious art, one must go far back into the history of the sect. The belief in revelation, the mystical awareness of the voice of God, or inner voice, may be traced to the Quakers and also to the heretical French Prophets, or Camisards, who militantly dissented from ecclesiastic formalism and authority; some fled to England early in the eighteenth century to escape persecution. In the practice of their faith that "all shall be immediately taught of God," these mystics of the Cévennes were subject to trances and strange ecstacies: "great shakings of the whole body, motions of the head, the arm, and the breast." "Instruments—recipients and transmitters of heavenly messages—arose in great numbers—cowherds, maidservants, common laborers, children—who "uttered large discourses, very pious, and strongly hortatory of repentence." Psalms were sung and miracles performed. People were amazed at the fine French speech of these illiterate peasants as they predicted the ruin of Babylon and the establishment of the true church. Charges of magnetism, satanic delusion, and hysteria were accompanied by persecutions similar to those experienced by the early Shaker church in England and America.[1]

An English branch of the Quaker faith which had been affected by the spirit of the French Prophets was the Wardley Society, under the leadership of James and Jane Wardley. The society's rites earned the worshipers the name of Shaking Quakers, or Shakers. Like the Quakers, the sect "practised no forms, and adopted no creeds as rules of faith or worship; but gave themselves up to be led and guided entirely by the operations of the Spirit of God."[2] Their meetings, like those of the Camisards,

[1] Sir Richard Bulkeley, "Letter to a friend," in *Prophetical extracts* (London, 1793–94), Part I, Introduction. The other parts are devoted chiefly to extraordinary prophecies, which seem to have been the chief and most remarkable forms of Camisard inspiration. It is noteworthy that the prophets were occasionally called instruments.

[2] Unless otherwise identified, all quotations referring to Shaker belief and practice are from early Shaker records.

were powerful and animated, attended with remarkable signs and operations, and with the spirit of prophecy and divine revelation. . . . Sometimes, after sitting awhile in silent meditation, they were seized with a mighty trembling, under which they would often express the indignation of God against all sin. At other times they were exercised with singing, shouting and leaping for joy at the near prospect of salvation. They were often exercised with great agitations of body and limbs, running and walking the floor, with a variety of signs and operations, and swiftly passing and repassing each other, like clouds agitated with a mighty wind.[3]

Ann Lee, a blacksmith's daughter and millhand, joined the society in Manchester, England, in 1758 and experienced visions that introduced deeper mysteries into that already mystical fellowship. The many extraordinary manifestations she was said to have received contributed to the formulation of the Shaker faith and established her leadership in the sect. She claimed that she had communed with the Lord Jesus Christ, that the whole heavenly world had been displayed before her, and that she had witnessed the very act of carnal transgression of Adam and Eve in the Garden of Eden, "the root and foundation of human depravity."

A revelation in 1774 directed her to go to America; the revelation was confirmed by numerous signs, one of which was a vision of a burning tree, later a theme in Shaker religious art (Plate I). On the voyage a storm threatened the safety of the ship, but two bright angels standing by the mast assured the prophetess that theirs was a ship of safety (Plate VIII). Other stories of ministering angels date from the forming of the first settlement at Niskeyuna (or Watervliet, New York) in 1776 and particularly from Mother Ann's missionary journey through New England in 1781–83. Just before her death in September, 1784, she saw her brother William (Father William, who had died the preceding July) coming in a golden chariot to take her to heaven (Plate VIII). Dreams and revelations were likewise ascribed to Father James Whittaker, Ann's chief disciple and her successor to the leadership of the society.[4] The peculiar "laboring"

[3] *A summary view of the Millennial Church* (Albany, (1823), pp. 4–5.

[4] The organizers or first leaders in each society were known as Mother or Father.

The idea of a dual Deity, a Father-Mother God, the feminine element of which was called Wisdom or Holy Mother Wisdom—"the Bearing Spirit of all the works of God"—may be traced to the early years of Shaker history.

The concept is an ancient one, however. According to cabalistic doctrine, which affected Jewish thought a hundred years before Christ, the Wisdom of the Eternal was a feminine deity whom the Hellenistic Jews called Sophia, or Sophia Sapienta. Bardesanes, who lived at the end of the second and beginning of the third century A.D., taught a similar doctrine, namely, that the first "emanation" from the Supreme Being, or Father of all things, was his feminine companion Sophia, or Wisdom; that from these two "proceeded seven

of the Believers in their religious dances and rituals was patterned on the dances of angels seen in a vision by Father Joseph Meacham, an American-born organizer of the Shaker church.

Visions, prophecies, and ecstatic experiences characteristic of primitive worship accompanied a Free Will Baptist revival in New Lebanon, New York, and vicinity (1779–80); there were many conversions, and an ordered society was eventually established. Singular revelations, clairvoyance, and the miracles of tongue-speaking and healing were again recorded at the time of the Kentucky Revival (1799–1805), which prepared the way for the founding of Shaker societies in Ohio and Kentucky. Visions were seen "in which the sun, moon, stars, mountains, rivers, plains, vegetables, fruits, animals and a thousand particular things and circumstances in nature were used as emblems of things in the spiritual world, or kingdom of Christ." Choice treasures were found, and the blessed partook of the fruits of the tree of life. The Shakers believed that such manifestations, no less than the visions of the ancient Hebrew prophets, the miracles at Pentecost, and the mystical experiences of the spiritual reformers of the seventeenth century, were signs of a new dispensation, a new heaven on earth. Among the first to be recorded was "A visionary dream by Eldress Marilla Fairbanks, Mt. Lebanon, 1806." Marilla became one of the most active instruments at the parent society. Probably the most widely circulated document of the kind was "A visionary dream by Garret K. Lawrence, Jan. 6, 1818." Lawrence was a botanist and one of the chief promoters of the famous medicinal herb industry at New Lebanon.

The ability to have spiritual experiences—through the gifts of clairvoyance, clairaudience, prophecy, and tongues—was a precious possession. Originating in Paul's First Epistle to the Corinthians, the term *gift* had wide application in

successive couples of emanations" led by Christ and his sister and spouse named Sophia Achamoth, or "Lower Wisdom" (L. Maria Child, *Progress of religious ideas*, New York, 1855, II, 394).

In Christian theology, the maternal element in deity, the *Mater Dei*, at one time was attributed to the Holy Ghost in the Trinity of Father, Son, and Holy Ghost. "This female quality [which was later called Sophia-Sapienta by certain early Christians] could not be completely uprooted, it still adheres, at least, to the symbol of the Holy Ghost, the

columba spiritus sancti" (Carl Gustav Jung, *Psychology and religion*, New Haven, 1938, p. 89). This quaternity (*Mater Dei* and the Holy Trinity), according to Jung, "appears early in ecclesiastical symbolism . . . the cross of equal branches included in the circle, the triumphant Christ with the four evangelists, the Tetramorphis, and so on. In later church symbolism the rosa mystica, the vas devotionis, the fons signatus and the hortus conclusus appear as attributes of the Mater Dei and of the spiritualized earth." (See Plate VIII.)

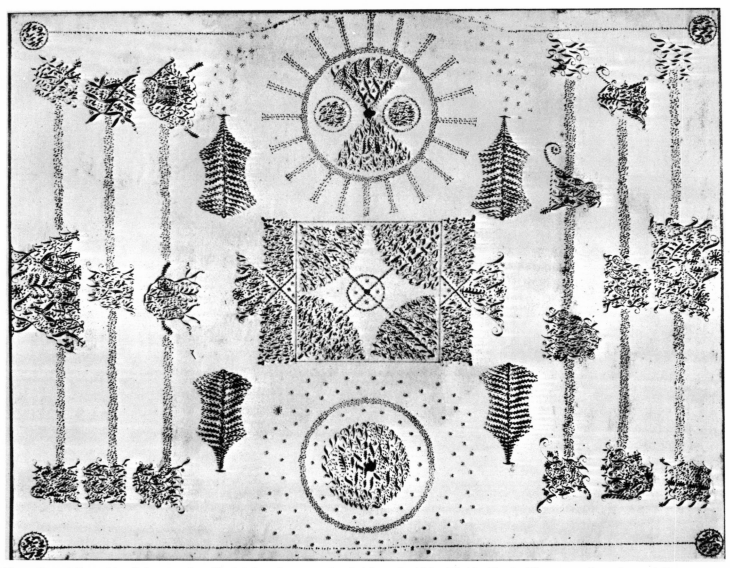

Fig. 1. Sacred Sheet. New Lebanon, 1843. Black ink, red accents; size: height, 14″; width, 17″. (Mr. Charles Thompson, Canterbury, N.H.)

INSCRIPTION ON BACK OF SHEET:

A Sacred Sheet, sent from Holy Mother Wisdom, by her Holy Angel of many signs, for Elder Ebenezer Bishop. Received March 9th 1843. Written March 20th 1843. In the first Order on the Holy Mount. Insts. Semantha Fairbanks and Mary Wicks.

Fig. 2. Sacred Sheet. New Lebanon, 1843. Black ink; size: height, 7⅞″; width, 13¹/₁₆″. (Shaker Community, Inc.)

Shaker experience. "Laboring for a gift" meant striving to become properly receptive of spiritual influence. The process of being "under operations," of inviting inspiration, was often accompanied by physical manifestations such as jerking the head, whirling, bowing, and shaking.

From the beginning of the movement reference was made to the gift of song. Songs inspired by deep conviction or received by revelation were called worship. The patterns were learned as gifts from angels dancing around the throne of God. Allusion was also made to the dancing gift, the whirling gift, the laughing gift, and the gift of love. Certain rituals were practiced from an early period: Under the influence of the warring gift, the worshipers stamped, hissed, and drove the Devil out of the room. The smoking gift commemorated Mother Ann's birthday. Inspired by the gift of signs, a member in meeting would "act over odd postures" and gesticulations, or would follow his outstretched arm to an appointed place or person. The gift of healing, according to Shaker tradition, was successfully exercised by the prophetess, her brother (Father William Lee), her chief disciple (Father James Whittaker), and other early leaders of the sect.

However, not until 1837 did Shaker spiritualism, unfolding its most remarkable phenomena, produce a true diversity of gifts and operations. On August 16, according to the records of the Watervliet society, some children in the South family, or Gathering order, suddenly became entranced and started to shake and whirl.

At 7-30 they were taken to their chambers for the night, but they soon began to sing and to talk about the angels. . . . The visions and trances continued from day to day, till many others became impressed with the same gifts. Under the direction of spirit guides they were conducted from place to place, and these guides conversed with those in the body, through the entranced persons. Without premonition they were taken on a visit to the Spirit Land, and as children, in their simple way, related all that they had seen and heard, to the great pleasure of their eager listeners. They had heard some beautiful singing, had seen some very pretty flowers, and had enjoyed a lovely visit with companions of their own age. . . .

An older class were soon passing away into visions and trances, and many others were exercised with a great variety of outward operations, such as bowing, whirling, and shaking. Some would speak of what they saw, or act as they saw others act, while in a visionary state. Many beautiful songs were learned.[5]

[5] Henry C. Blinn, *The manifestation of spiritualism among the Shakers, 1837–1847* (East Canterbury, N.H., 1899), pp. 15–16.

In the next six months the manifestations spread to the communities at New Lebanon, New York; Hancock and Tyringham, Massachusetts; Canterbury and Enfield, New Hampshire; and elsewhere in New England. It is difficult to prove the Shaker theory of supernatural contagion for the manifestations; it is easier to believe that the phenomena, due to a common spiritual condition and accepted by the ministry as genuine, were encouraged by the "lead."[6] The visions, trances, and gifts in the eastern societies were reported to the Union Village, Ohio, ministry in January, 1838. That an outbreak did not occur there until August 26 of that year perhaps indicates that the stage had to be set. The inspired ones obediently followed the direction of the elders and perhaps at times flattered them in their writings. Yet one cannot escape the conviction that at the time all were undergoing at different degrees a profound mystical experience.

By the beginning of 1838 visionary, gift, or "extra" songs and tunes, sometimes in unknown, or "native," tongues, were being recorded in great numbers. In many instances they were ascribed to Mother Ann or to other early leaders; sometimes they were attributed to Biblical prophets or to famous individuals.

Instruments now appeared as messengers and as interpreters of the divine will. In some cases these influential "vessels of God's word" came into prominence as self-constituted singers and prophets, but usually they were appointed and their office was approved by the presiding ministry (composed of two men and two women) or by the family elders, "the holy anointed ones of God." According to one account, a simple ceremony attended such appointments: "those who received this gift were called before the ministry, pronounced worthy, and received on their knees, by imposition of hands and other appropriate motions, the crowning and clothing appropriate to the official capacity in which they were to act." The instruments were further informed that they must go forth in "union with their visible lead, this to be the test as to the quality of their gifts."[7]

[6] "The Holy Anointed at Holy Mount, (or New Lebanon,) are called and chosen to stand as the first and leading Ministry, in the Zion of God upon earth; unto whom all other orders of the Ministry, in all other societies of Believers are accountable for all their transactions of an official nature" ("Millennial Laws", Part I, Sec. II, quoted by E. D. Andrews in *The people called Shakers*, New York, 1963, p. 254).

[7] David R. Lamson, *Two years' experience among the Shakers* (West Boylston, Mass., 1848), p. 51. Lamson and other critics of Shakerism insinuated that the instruments were often selected by the elders as mediums of propaganda to strengthen and increase their own authority.

This select group was responsible for most of the songs and messages as well as for the drawings which are the subject of the present study. Its sacred obligation is thus prescribed in "A general statement of the Holy Laws of Zion" (1840), the earliest major communication of the chief instrument at New Lebanon, New York, Philemon Stewart:

1. Bow down your hearts and give ear unto me, all ye who have been, or may here-after be used as mouths, or instruments in my hand, to sound aloud my holy trumpet in Zion, that ye may learn true *wisdom*, that which cometh from me and my eternal brightness, saith the Lord.

2. I do require that whenever you feel my spirit upon you, you should exceedingly fear and tremble in my presence, and in the presence of your heavenly Parents and the holy Angels, whom I have and forever will clothe with *my Spirit* and *my Word*.

3. Take heed unto your ways, saith the Lord, that ye sound forth nothing in *my name*, or that of your *heavenly Parents* [Jesus and Mother Ann Lee], but with what is in strict accordance with the line of my anointing upon earth, which I have established for the protection and Salvation of souls—for this my hand hath appointed, saith God your Heavenly Father.

4. I do also require that all ye who have been chosen as instruments, should suffer and wade in *deep deep* tribulation, that your passions and your natural feelings may be under the greatest degree of mortification, that they may not blend, in any way, with my Spirit or gift to lead you astray.[8]

5. Lest instead of speaking that word which I, through your heavenly Parents, or the holy Angels in Heaven, have given you to speak, you sound forth your own word, blended with your own natural feelings and senses, and that in my name, to please the natural feelings and cravings of those that may hear you, or the cravings of your own fallen natures, which may have a great desire to be the bearer, or instrument, to reveal some great and hidden mystery, that your names might be sounded abroad, as being the bearers of that which God had, for ages, kept concealed from mortals, and now has revealed them through you.

6. The enemy has taken great advantage of souls, in many places, in this respect, of them that had been instruments through which my word of truth, and beautiful gifts, have been conveyed.

7. The laws of Wisdom do forbid, saith the Lord, that the names of instruments, in any particular gift or communication, should be retained by any save the Ministry and Elders.

8. I do require, saith the Lord, that the Ministry and Elders do labor, in every place, to direct these things according to true wisdom, that the Holy Spirit be not quenched, nor the soul be lost.

· · · · · ·

13. But I do require you all, saith the Lord, to keep closely united to your Elders, and be

[8] A warning against false or "pretentious" revelations, which plagued the Shaker society, as it did the Amana Community of True Inspiration. Compare the case of Barbara Heinemann, the *Werkzeug* of that community (Bertha M. H. Shambaugh, *Amana that was and Amana that is*, Iowa City, 1932).

truely sincier in all that you do. Don't let your minds run and ponder upon great and hidden things; but labor for my pretty little, simple and solemn gifts.

14. And whenever you feel the influence of my invisible hand upon you, in any particular gift or communication which you are required to make, go and communicate it freely to your Elders, (or if it be in meeting, with their union) and my spirit shall direct you aright. For by keeping and walking in that sense of which I have spoken, there can no evil influence come upon you.

15. And I do furthermore require, saith the Lord, that every soul in Zion should be filled with my holy fear, and labor, at all times, to possess a sacred and solemn sensation, whenever they are in the presence of any who are under particular and immediate influence of my holy and invisible powers.

16. All heavy walking and loud talking I do forbid, at such times, saith the Lord, or talking any upon things that are foreign from your duty in that place; for if ye do, you will lose that sacred reverence which I do require you to keep at all such times.[9]

Spiritual gifts were glowingly described by the instruments in their oral transmission of messages first received at the Church family, New Lebanon, in April, 1838. Isaac Youngs, the church historian, wrote of them as follows:

Another extraordinary class of spirit manifestations was the giving of spiritual presents . . . bearing the names of material things, as Gold Leaf, paper, pens, books; musical Instruments, fruits of all kinds, flowers, roses, Diamonds, numerous articles of Ornament-boxes, baskets-Implements of hand labor, as sythes, rakes, &c. — Weapons of war, guns, swords, spears, &c. and sacks, full of all kinds of rich treasures. [Also spiritual wine] which caused a great evidence of its reality, by the paroxysms of intoxication that it produced; causing those who drank it to stagger and reel, like drunken people.[10]

As givers of gifts, the spiritual parents of the Shakers, Father Joseph Meacham and Mother Lucy Wright, "began to be more manifest" and included in their presents "Love at numerous times — manna — vials of Balsam — Robes — many articles of ornament, as Stars — boxes of gifts assorted — Ponies, etc. etc. perhaps more than 100 kinds."[11]

Songs, visions, and messages increased in number in 1839. That year the burial service was dignified. "The departed spirit addressed the assembly,"

[9] MS, The Edward Deming Andrews Memorial Shaker Collection in The Henry Francis du Pont Winterthur Museum, Winterthur, Del. Cited hereafter as Andrews Coll. Archaic spellings are common both on the drawings and on Shaker manuscripts; these spellings have been retained without using the designation *sic.*

[10] "A concise view of the Church of God and of Christ on earth . . . ," New Lebanon, [N.Y.], 1856, Andrews Coll.
[11] *Ibid.*

The Tree of Light or Blazing Tree. Oct. 9th 1845.*

The bright silver color'd blaze streaming from the edges of each green leaf, resembles so many bright torches. N. B. I saw the whole Tree as the Angel held it before me as distinctly as I ever saw a natural tree. I felt very cautious when I took hold of it lest the blaze should touch my hand.

Seen and received by Hannah Cohoon in the City of Peace Sabbath Oct. 9th 10th hour A.M. 1845, drawn and painted by the same hand.

*The conception of the blazing tree may have originated in the account of the burning bush seen by Moses. It seems more likely, however, that it was inspired by an episode in the life of Father James Whittaker who wrote:

"When we were in England, some of us had to go twenty miles to meeting; and we traveled nights on account of persecution. One Saturday night, while on our journey, we sat down by the side of the road, to eat some victuals.

"While I was sitting there, I saw a vision of America, and I saw a large tree, and every leaf thereof shone with such brightness, as made it appear like a burning torch, representing the Church of Christ, which will yet be established in this land" (Testimonies of the life, character, revelations and doctrines of our ever blessed Mother Ann Lee, and the elders with her . . . , Hancock, 1816).

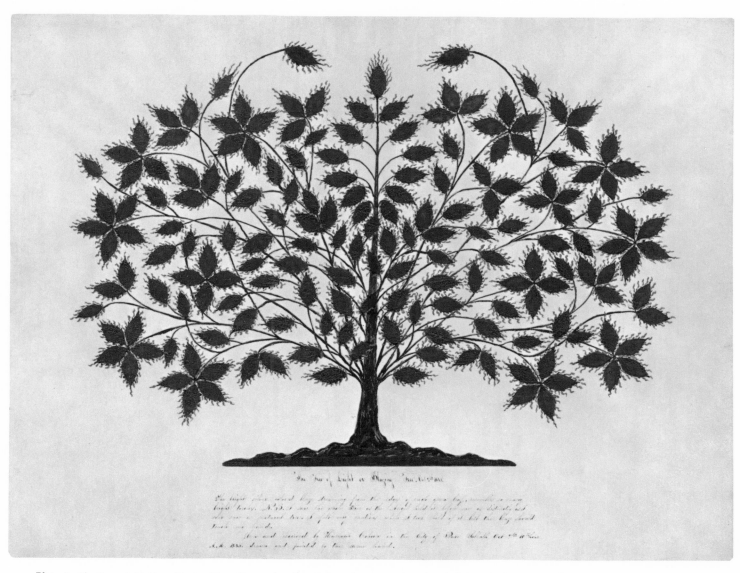

Plate I. *The Tree of Light or Blazing Tree.* Hancock, 1845. Ink and water color; size: height, 18⅛″; width, 22⁹⁄₃₂″. (Shaker Community, Inc.)

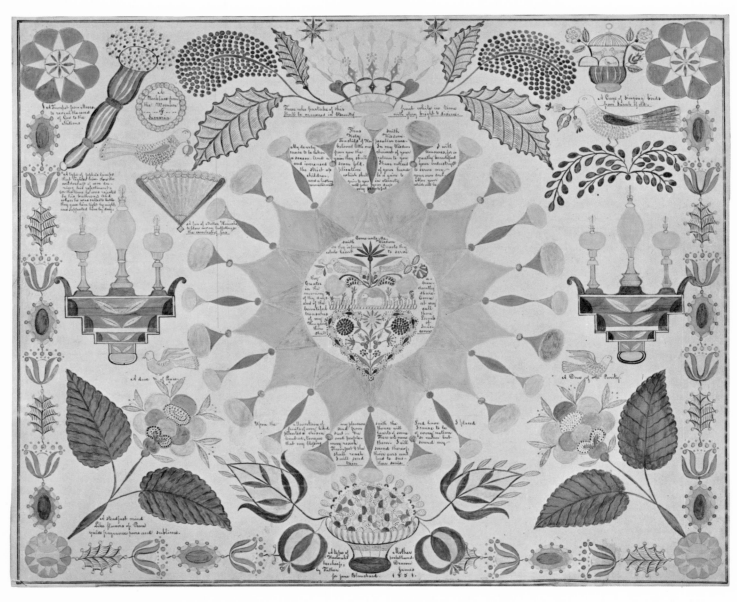

Plate II. *A Type of Mother Hannah's Pocket Handkerchief.* New Lebanon, 1851. Ink and water color; size: height, 14³/₃₂″; width, 17¹/₁₆″. (Shaker Community, Inc.)

TOP, CENTER:

Those who partake of this fruit while in time
Shall be crowned in Eternity with glory bright
 & divine.*

Thus saith Holy Wisdom. To a child of Her peculiar care. My dearly beloved little one, In my Wisdom I will cause to be taken from you the choicest of your treasures, for a season. And again they shall return to you greatly beautified and increased seven fold. I have noticed your industry; & the strict application of your hands to serve my children, which shall be a gain to your own soul, and a lasting gain to you in eternity. Also your reconciled mind will form your dress which will be very beautiful

TOP, RIGHT:

A Cage of Singing birds from Sarah of old.

WITHIN CIRCLE, CENTER:

Come unto Me, saith Wisdom in thy infancy. Devote thy whole heart to serve thy Creator in the morning of thy days, and of the beautiful treasures of my Kingdom thou shalt abundantly share. Come at my call thou Lamb of Innocence.

BOTTOM, LEFT:

A dove of Peace.

 A steadfast mind
 Like flowers of Peace
 Yields fragrance pure and sublime.

To right of central trumpet design:
A Dove of Purity.

Below central trumpet design:
Upon the mountain of my pleasure saith the Lord have I placed fruits of every kind. And from thence will I cause to be planted a chosen seed in the hearts of some of every nation, kindred, tongue and people. There are none so mean but that my blessing may reach them. I will sound my Trumpet & the sound thereof shall reach their ears and I will send food to sustain their souls.

A type of Mother Hannah's pocket handkerchief, Drawn by Father James for Jane Blanchard. 1851.

TOP, LEFT:

A Trumpet from Moses, to reveal the word of God to the Nations

A Necklace from the Woman of Samaria

A type of Jepha's lamps that lighted him thro' the wilderness of woe during his rejectment, (or the time he was rejected by his brethren.) And when he was called to battle they gave him light by night, and supported him by day.

A fan of Mother Hannah's, to blow away buffetings: the cruelest of foes

This drawing was possibly the work of Eunice Wythe, a New Lebanon sister, who was one of the first followers of Mother Ann. On the reverse side of the sheet is a "Copy of a Short Hymn, composed by Eunice Wythe Soon after the aforementioned vision in 1815"; also lines "Written by Eunice Wythe, after attending the Church meeting at Holy Mount, 1850." The following excerpt from the 1850 hymn has a relation to the drawing:

O Heavenly Vision, Glorious Sight,
My soul is enraptured with purest delight
With the Angelic visage of a heavenly throng
Of Celestial order, tho to earth they belong.

It is heaven complete, tis a paradise new,
When my spirit these happified numbers can view
And mingle in praise with saints on the earth,
In shouts of thanksgiving & songs of sweet mirth.

My spirit to earth, with joy take its flight . . .

Youngs wrote, "communicating their love and thanks, and the expression of their feelings on meeting with this great change." Waxing more serious and portentous, the messages were recorded in writing in 1840, usually by scribes who prepared copies for distribution in the society. On May 3 the first communication was received in the name of Holy and Eternal Mother Wisdom.

Also beginning with 1838, the religious dances developed new forms and took on greater significance. Sometimes performed silently and sometimes with chanting accompaniment, but usually with special dance-songs, the marches and circular dances expressed more than ever before the joy of living the Shaker life.

Manifestations increased in intensity and frequency in 1841. There was a profusion of writings, some of which, like the injunctions on food and drink reform,[12] affected the secular life of the order. Attention was given to gifts at any time, not only in meeting. In this year, too, the first of the revival rituals was instituted, the so-called cleansing gift, described by Youngs as follows:

It was also the season of the year, [near its close] for the yearly Sacrifice, or general opening of the mind: on this subject there was a sacred writing bro't forward, entitled the Judgment Law, enforcing much solemnity on that labor.

After this a very solemn and mortifying scene was enacted, in the work of purifying our habitations as well as our souls.—A chosen band of Instruments and singers went thro-out our dwellings & all our buildings, singing a song of vengeance against the abominations that had rested in Zion—& sweeping, (making the external motions) and cleansing every place, or under evry roof; and in the place of worship all got down on their knees, to "scour and scrub"—"from the floor, the stains of sin."

A similar ritual, The Midnight Cry, was instituted the same year at New Lebanon and was retained for ten years. During the ceremony, which lasted about two weeks, a company of twelve instruments with two leaders carrying lamps marched through every room in every dwelling. At midnight on the third day a group of four sisters sang as they passed through the sisters' apartments. At two o'clock the next night a company of brethren and sisters again aroused the family, who gathered in the meeting room at three in the morning for an hour of worship.[13]

[12] "Swine's flesh was rejected, and all ardent or stimulating drink was discountenanced, tobacco, foreign teas, in great measure" (Ibid.).

[13] "The Midnight Cry" was the title of a Millerite paper published at this same time. Crude cuts of angels blowing trumpets and other emblems embellished the periodical, but there is no evidence that the Shakers copied either the title or the illustrations.

The culmination of religious ecstasy was reached between 1842 and 1845. In 1842 feast days on sacred mounts and the rites of "taking in the spirits" and the sowing of spiritual seeds were first observed. Meetings became so extravagant that they were closed to the public. On New Year's Day, "a day in which the wonderful display of divine manifestations from the spiritual world to mortals, is perhaps at its height," [14] Holy Mother Wisdom retired with the Ministry at New Lebanon and communed with them through instruments.

Early in the year each society was instructed to select an elevated site within its domain, a hill or mountaintop, for special observances in the spring and fall. These sacred feast grounds were cleared, leveled, and enclosed. An inner hexagonal plot called the "fountain" was surrounded by a low fence and marked at one end with a marble slab — The Lord's Stone — appropriately inscribed.

The revelations of the instruments, the shouts and songs, the remarkable gifts and sacraments, and the intense emotionalism of the votaries invest these mountain revivals with a fabulous quality. On the morning of a feast day, the Shakers, clad in their "holy passover" robes,[15] left their homes and, singing and dancing as they went, marched two abreast up the holy hill. The ceremonies around the fountain abounded with gifts: a "flameing trumpet — which the Savior placed upon each of our shoulders"; a box of spectacles for each "that they may see more clearly spiritual things"; "a basket of Father Job's love to be placed upon Elder Nathaniel's spiritual staff for the brethren and sisters to come and partake of freely"; a gift of heavenly wine; "a beautiful Gold Chaine from the Prophet Samuel, to put around our necks, with his love in it"; swords "to divide flesh and spirit"; "cups of tribulation"; a box of spiritual guns from George Washington for the brethren.[16,17]

Among the rituals was the sowing of spiritual seed. From small "papers" of seeds or "baskets" on their arms, the worshipers "had liberty to go forth and sow whatever they were willing to reap" and on their return "to reap the growth," — the "full share of blessings."

One innovation in 1842 was called "taking in the spirits" and was first revealed

[14] Youngs.

[15] Spiritual dresses.

[16] "On these being received the brethren begun and moved on, with the activity of good marksmen against the enemy, they were very nimble and shure in loading. As I believe there was not one shot that misfired" (Manuscript records, Hancock and New Lebanon).

[17] All of these ceremonies were carried out in pantomime. For instance, "On the evening before the great day, spiritual garments were distributed to all 'purified souls.' As each brother knelt before the presiding elder, he received, from an imaginary chest, a coat . . ." (E. D. Andrews, *The people called Shakers*, New York, 1963, p. 162).

RECTO:

Mother Ann's Word to her little child Elizabeth Cantrell. Written August 14th 1848.

Draw near unto me my affectionate little one, and hear thy Mother's word unto thee, for I have a ball of love and blessing to give thee, to encourage thee to be faithful in the way of God; and I will also give thee a shining Lamp of pure gold to light thee on thy way through this world of wickedness below. Stand fast my beloved child, thro' all the trying scenes that thou art called to pass through, and keep thy faith most holy, and thou shalt receive thy reward in Heaven. Thou hast good faith which will carry thee thro', if thou wilt walk in obedience there unto. Thy privilege is great, and thou must always keep it, and be a shining light in thy Mother's House on earth. Then bright Angels shall stay with thee and administer unto thee in the hours of temptation and trial which thou wilt have to meet which often times will feel severe to thee. But flinch not, and give not back Press ahead and go through.

VERSO:

hold out to the end and thou shalt be clothed in white robes, and dwell with holy Angels in the mansions of purity and love, harmony and peace, where nought can disturb thy quietness or do thee any harm. Thou shalt walk in pleasant paths, in beautiful vallies and delightful gardens, and feast on the fruits of heavenly comfort, which will have no end if thou art faithful. And thou canst also play upon thy harp and be joyful in the God of thy salvation. So let thy labour in this world be to prepare for another, and weave the garment that thou art willing to wear in eternity, for all must meet the judgement day. Farewell in my Sweet love, says Mother Ann.

Be my little harmless Dove,
And keep thy Mother's pretty love
Let not any thing allure,
Or take away thy birthright pure
Hold unto my golden Cross
While on times wide Ocean toss'd
Always walk the valley low
There pretty flowers always grow.

Note emblems: ball, lamp, harp, dove, treasure chest, golden cross, ship, flowers, and an angel in bright raiment carrying gifts.

Mother Ann's Word to her little child
Elizabeth Cantrell. Written August 14th 1848.

Draw near unto me my affectionate little one, and
hear thy Mother's word unto thee, for I have a ball
of love and blessing to give thee, to encourage thee to be
faithful in the way of God; and I will also give thee a shining
Lamp of pure gold to light thee on thy way through this world
of wickedness below. Stand fast my beloved child, thro' all the
trying scenes that thou art called to pass through; and keep thy
faith most holy, and thou shalt receive thy reward in Heaven.
Thou hast good faith which will carry thee thro', if thou wilt
walk in obedience thereunto. Thy privilege is great, and thou
must always keep it, and be a shining light in thy Mother's
House on earth. Then bright Angels shall
stay with thee and administer unto thee
in the hours of temptation and
trial which thou wilt have to meet
which often times will feel severe to thee.
But flinch not, and give not back
Press ahead and go through.

Fig. 3. *Mother Ann's Word to her little child Elizabeth Cantrell. Written August 14th 1848.* New Lebanon, 1848. Ink and water color on cream-colored paper; size: 7½″ square. (Shaker Community, Inc.; photograph, Geoffrey Clements.)

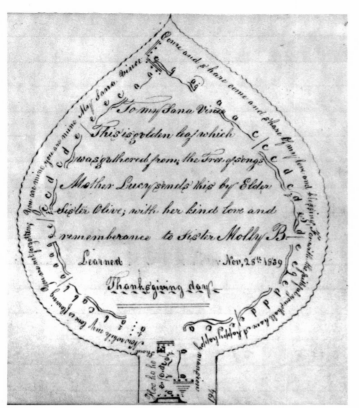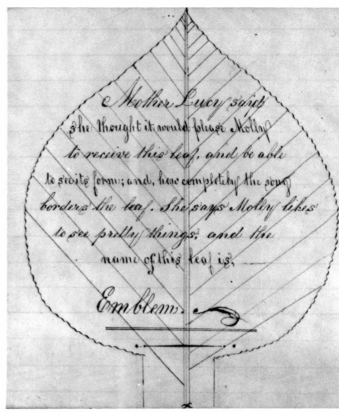

Fig. 4. Leaf Sketches. Pages in a song-book written by Mary Hazard. New Lebanon, 1839. Blue ink; size: height, 5″; width, 3½″. (Edward Deming Andrews Memorial Shaker Collection in The Henry Francis du Pont Winterthur Museum; photograph, Geraldine Sharpe.)

LEFT:

Border of leaf:

Come and share come and share Of my love and blessing, For with the faithful you shall have A happy happy mansion Hoo ho ho Shout Now while my love is flowing You are not forgotten; You are mine, you are mine My Sana Vince.

Within leaf:

To my Sana Vince

This is golden leaf which was gathered from the Tree of songs Mother Lucy sends this by Elder Sister Olive; with her kind love and rememberance to Sister Molly B.— Learned Nov, 28th 1839 Thanksgiving day

RIGHT:

Mother Lucy said she thought it would please Molly to receive this leaf, and be able to see its form; and, how completely the song borders the leaf. She says Molly likes to see pretty things, and the name of this leaf is,— Emblem.

in the mountain meetings. In this gift, to follow Youngs's account,

the departed spirits, those who have left the body, and such as have not received the gospel, by which they, (the spirits) take possession of those in the body, by which the mortal Instrument became as it were completely lost to his or herself, and changed into the spirit that controlled them, acting as did that spirit, while in the body.

. . . They came of many, and various nations, particularly the [Indian] natives of this land. Some were very rude and wild, and caused their Instruments to conduct with much eccentricity — sometimes serious and sometimes amusing.

After these visitations, many songs were composed in native tongues. The machines which sometimes appear in the drawings may also have their origin here. While he was a member of the Enfield, New Hampshire, community, Hervey Elkins had a vision of some of "the aboriginal inhabitants of America" depositing in the center of the sanctuary "a pile of spiritual machines made for the purpose of grinding to pieces . . . old nature, as the Shakers term the evil, sensual principles in man. Each was requested to get one of these invisible engines and metaphorically try them, to see how they would work." Symbolic terms used by the Enfield Shakers were the wine of the Spirit; mantles of grace; garments of righteousness; gospel shoes and moccasins; spiritual gloves, cravats, and handkerchiefs; helmets of strength; breastplates of protection; pipes of peace ("for smoking Mother's love"); snuff boxes ("containing Mother's Love in a pulverized state"); baskets of simplicity; and lilies of love. "Some of the Shakers," Elkins declared, "suppose that these things exist tangibly and visibly to spirits; others suppose they are merely metaphorically used, to render properties conceivable to those who cannot appreciate them without." [18]

The mountain meetings often ended with a spiritual feast, with long "tables" spread with spiritual food with which the worshipers refreshed themselves after their prolonged exercises (Plate VI). In one account the repast consisted of apples, pears, peaches, pineapples, plums, cherries, apricots, grapes, strawberries, whortleberries, "pomgranits," oranges, pies, sweet cakes, bread and butter, honey, locust and wild honey, milk and honey, white wine, and manna.

The love feasts were sometimes preceded by mysterious heavenly signs that recalled the visions seen in the early years of the Shaker sect. An example is recorded in "A Domestic Journal of Important Occurrences Kept for the Elder

[18] *Fifteen years in the senior order of Shakers* (Hanover, N.H., 1853), p. 114.

Sisters Beginning January, 1842. New Lebanon." The entry is dated May, the day before the feast:

Last night about one oclock A.M. a wonderful sign was seen in the heavens; a large cross, passing across the moon, a large ball or body of light at the ends of the cross, and then a bow over the moon connecting those two lights together. Thus:

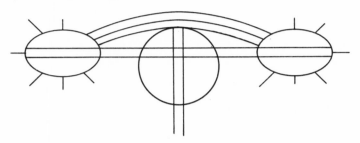

Such signs may have inspired certain symbols used in the drawings and paintings.

The manifestations continued unabated through 1845, when the public meetings, closed in 1842, were again opened. The Shakers went to the mount twice each year and attended to the yearly appointment of sweeping and cleansing. New gift songs were composed, new modes of exercise in worship were introduced, and in the meetings inspired writings were read frequently.[19] "The forepart of the year 1843," Youngs wrote, "was remarkable for the display of mysterious signs, such as sounding of trumpets, exhibiting different colored sheets, cloths, etc. and wearing different colored girdles, etc." The next year there was "a work in the name of the Father, to awaken, to warn, & to notice the people, individually, particularly by a writing, in form of a *heart*, and also by a short message, spoken by an Instrument" (Fig. 6). As late as 1847 sources refer to new prophecies and gifts, such as the washing of one another's feet.[20]

[19] Gift songs were frequently accompanied by a spiritual present: "Wisdom's Pleasure" was "Printed upon a piece of gold by holy Wisdom brot by Mother Ann and presented to Sister Rachel and Betsey, for a special notice to all between 60 and 30." "Wisdom's Harp" was "written upon a harp that holy Mother Wisdom gave to the Elders, in the Second Order." "Mother's Cake of Love" was "learned from a cake of love presented from Mother Ann to Leah Taylor" (MSS, Andrews Coll.).

[20] In a "remarkable prophecy" at the Canterbury society on Christmas day, 1847, Margaretha Stoffel proclaimed that "successive revolutions in Europe" were imminent, and that "republicanism and free principles" were about to usher in the "final millennium of the world." Other events prophesied at different times were the death of Lafayette, the invention of telegraphy, the Emancipation Proclamation, and the assassination of Lincoln.

With an increase in the process of spiritual regeneration as embodied in the manifestations, ceremonies, and gifts, other ceremonials comparable with the mountain feasts were instituted; chief among these were the family meetings held in many societies on Christmas Day. These celebrations reached a climax in 1845[21] and are interesting, among other reasons, for the wealth of source material they must have provided the artists, who began to do more work about this time. Most of the Christmas gifts came from the Holy Saviour through the instruments and were received with the surprise and gratitude which would have accompanied the reception of material presents. A random selection from various Shaker writings[22] indicates their nature. "All the rich gifts and heavenly blessings which were given to us," one record states, "are more than can be told."

At one meeting love and humility were gathered from baskets as one would gather material things. Fruit was plucked and eaten; spiritual wine was drunk; brooms and swords were wielded; golden trumpets sounded; and mantles of protection, strength, comfort, or light were wrapped around the body. Then "the brethren and sisters formed a circle in their respective parts of the room, while the Angel bound each circle with a chain of love, fastened by the clasp of obedience." On another occasion Mother Lucy brought a ring of flowers (Plate III)[23] "for each of the ministry to place around their necks."

At another meeting the gifts included bright silver crosses, large silver sacks filled with the bread of life and attached to the recipients by gold cords, pitchers and bottles "filled with never failing waters to be put into the sacks," "gospel fire" blown by clapping the hands, bowls of celestial wine, and choice fruits eaten around the sacred table. A bundle of brooms was received from "Br. George Washington[24] for each one to sweep and clean the house with," and a comb of honey "procured by the white bees and sweetened by Elder Nathaniel's love was placed on the altar" and then distributed to the company. "A bright glorious crown" with a golden chain was presented to each member of one

[21] The date of all the Christmas records in our library. "An extraordinary gift of devotion, repentence and spiritual givings [occurred] on this Christmas, which extended thro' out the societies of Believers" (Youngs).

[22] Chiefly from the City of Peace, the City of Love, and the City of Union, the spiritual names of the societies at Hancock, Mass.; Tyringham, Mass.; and Enfield, Conn.

[23] Mother Lucy Wright and Father Joseph Meacham succeeded Mother Ann and Father James Whittaker as the dual "Lead" in the society.

[24] The Believers greatly admired Washington, who was supposed to have received the Shaker gospel in the spiritland.

family. Also received was "a beautiful star from the Saviour stamped upon the forehead, surpassing all earthly beauty." For selected recipients were a bowl of refining fire, a bundle of rods, and bright stars. A beautiful garden appeared, filled with all kinds of "the most delicious and fragrant flowers."

On still another occasion came "a beautiful flock of little white doves from Holy Mother, with a small branch in their mouths, for each one of the brethren and sisters. . . . This is a token of her love," said the instrument, "you may receive a branch by holding out your right hands." Among the gifts were "seeing glasses, to see spiritual light"; a carpet of Mother's love "soft as velvet"; a bowl of golden plums "picked from the Saviour's vine"; cakes of love; honey sweetened by love; a basket of grapes from Father William, a cluster for each of the brethren and sisters; olive branches, books, burning rods, rings of love, and gloves of fire.

Though the religious culture of the Believers was complicated by the most powerful ardors, such forces did not reduce the meetings into a harlequinade. An instinct for order characterized all phases of Shaker life, including the sacred ceremonials, and certain traditions and controls developed under the guidance of the "lead." This feeling for arrangement is revealed in the drawings as a sense of design.

The content of the inspirational drawings is illuminated somewhat by the messages recorded by instruments and scribed from 1840 until the middle of the next decade. Since these instruments and their gifted associates later turned to graphic means to communicate their visions, much of the substance and purpose of their art may be learned from a study of their inspired writings.

The earliest message on record is one from Philemon Stewart, the New Lebanon seer. On the afternoon of April 22, 1838, he was supported into a Sabbath meeting by two brethren and under "great operations of divine powers" spoke to the congregation in the name of Mother Ann. From then on, literally hundreds of communications were carefully preserved; some, like Stewart's "Holy Laws of Zion" and *A holy, sacred and divine roll and book*, became major compendiums of mystical testimonies. Much of this material, it is true, consists of wordy homilies. Nevertheless, the soul of "A chosen People" conscious of destiny shines forth from these didactic epistles and, to an even greater extent,

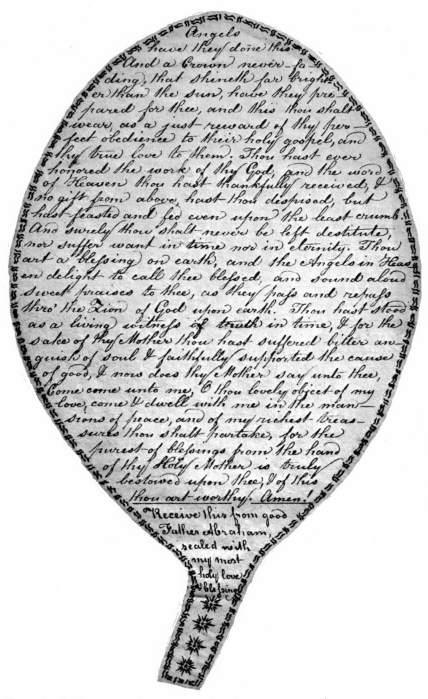

Angels have they done this. And a Crown never fading, that shineth far brighter than the sun, have they prepared for thee, and this thou shalt wear, as a just reward of thy perfect obedience to their holy gospel, and thy true love to them. Thou has ever honored the work of thy God, and the word of Heaven thou hast thankfully received, & no gift from above, hast thou despised, but hast feasted and fed even upon the least crumb. And surely thou shalt never be left destitute, nor suffer want in time nor in eternity. Thou art a blessing on earth, and the Angels in Heaven delight to call thee blessed, and sound aloud sweet praises to thee, as they pass and repass thro' the Zion of God upon earth. Thou hast stood as a living witness of truth in time, & for the sake of thy Mother thou hast suffered bitter anguish of soul & faithfully supported the cause of good, & now does thy Mother say unto thee, Come come unto me, O thou lovely object of my love, come & dwell with me in the mansions of peace, and of my richest treasures thou shalt partake, for the purest of blessings from the hand of thy Holy Mother is truly bestowed upon thee, & of this thou art worthy. Amen! Receive this from good Father Abraham, sealed with my most holy love & blessing.

Fig. 5. Leaf gift, or reward (verso reproduced). New Lebanon, 1844. Green paper; size: height, 6½″; width, 4″. (Location unknown.)

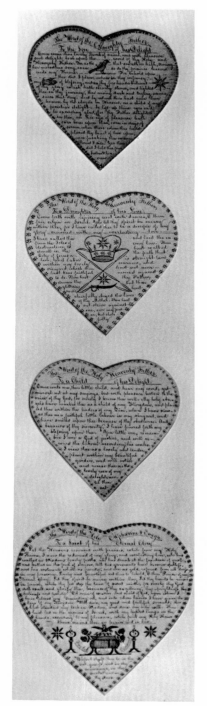
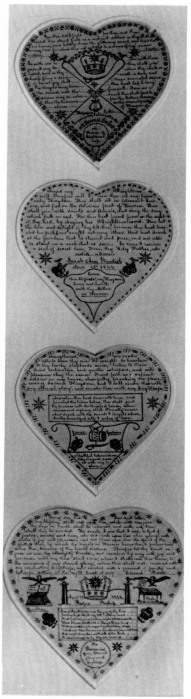

Fig. 6. Heart gifts, or rewards. New Lebanon, 1844. Ink; sizes: (A) height, 4^{11}/$_{16}$″; width, 4^{11}/$_{16}$″; (B) height, 4″; width, 4^{1}/$_{16}$″; (C) height, 4″; width, 4^{1}/$_{16}$″; (D) height, 3^{15}/$_{16}$″; width, 4″. (Shaker Community, Inc.; photograph, Geoffrey Clements.)

A, RECTO:

The Word of the Almighty Father,
To the Son of his Delight.

Come come thou lovely Lamb of mine, and with pleasure and delight, look upon the word of thy Holy and Heavenly Father. For as the Lark that soareth on high, tuning her melodious song, even so do thy praises ascend unto my Throne. For behold upon thee did I place, when in thy infancy, my [hand] of blessing, and on thy forehead a briliant [star] of my glory which hath clearly shone, and lighted thee on thy journey, thro' many dark and trying scenes, since that day: and by which thou hast ever been known, by the Angels in Heaven, as a child of my peculiar delight. So lift up thine eyes and be exceeding glad, for thy Father delighteth in thee, an his eye of pleasure hath ever been on thee, even in days of sorrow, when those whom thou hadst placed thy heart of love upon, were forsaking thee on every hand & side. Yea then did I hold thee from Satan & his crew.

A, VERSO:

Yea then did I fight for thee, and then didst thou stand forth as a valiant soldier in thy Mothers house, and boldly drew the glittering sword, and laid the enemy low; for which thou art entitled to a crown of my never ending love.

Left of crown:

So with me rejoice, O my beloved, and on thy harp play a song of sweet joy, that the Angels may hear the sound, and the same may re-echo thro' the heavens above.

Right of crown:

For with them thou shalt join when thy work on earth is done and times sorrowful scenes thou hast bid a long farewell. Then as a lamb thou shalt feed, before thy Fathers Throne, on the choicest fruits of Heaven.

Beneath harp:

Benjamin Gates. So come my beloved & enter into the joy of thy Lord.
A Prince of Righteousness.

B, RECTO:

The Word of the Holy, Heavenly Father,
To a Daughter of his Love.

Come forth with rejoicing and with dances, O thou fair virgin in Israel. Yea let thy spirit be merry within thee, for I have called thee to be a disciple of my glory crowned with my everlasting Love.

Left of crown:

I have called thee from the Isles of destruction to dwell in the City of Jerusalem, and labor within my lovely vinyard which thou hast been faithful to do. Thou hast drawn the glittering sword,

Right of crown:

and laid the enemy low. Thou hast walked the path that is straight and narrow, and hast not murmured against thy Father; but thou hast

Beneath sword:

cheerfully obeyed the laws of thy Mother. Thou hast not strove against me, nor my power, but cheerfully

B, VERSO:

obeyed my All righteous will. Therefore will I own thee in my heavenly Kingdom. Thou shalt sit in pleasant bowers and feed on the delicious fruit of Heaven. Thou shalt join with saints and Angels, and sing the song which hath no end. For thou hast found favor in the sight of thy Lord, by obeying his All righteous word. Thou art the love and delight of thy Mother, because thou hast traveled her path, and sought not any other. And hast drank at the fountain that is eternal and pure, and art able to stand on a rock that is sure. So come & receive a seal of sweet love, From thy Holy Father, who ruleth above. Sarah Ann Standish April 15th 1844
Come thou blessed of my Kingdom, Come and dwell with thy Mother in Heaven.

C, RECTO:

The Word of the Holy Heavenly Father,
To a Child of his Delight.

Come unto me, thou little child, and hear

my word, yet marvel not at my sayings, but with pleasure listen to the voice of thy God, for surely I know thee well. My holy Angels have marked thee as a child of my Kingdom, and placed thee within the borders of my Zion, where I have viewed thee as a faithful little laborer in my vinyard, and have smiled upon thee because of thy obedience. And because of thy sincerity, I have poured forth my blessing upon thee. Yea little one, remember I am a God of justice, and will reward the laborer according his works. I view thee as a lovely and tender plant within my beautiful garden, and will notice and nurse thee as the lovely rose of my delight, until thou art

C, VERSO:

strengthened, and made able to bear thy own weight. So hearken to thy lovely shepherds voice, listen to their kind entreaties, and gentle whispers, and with pleasure obey the same. Stand forth as a valiant soldier in my house, cheerfully forsaking the pleasures of Satan's Kingdom, and I will crown thee with my eternal glory, and enrobe thee with my brightness.

In box:
And when thou hast done with time, and finished thy labors below, thou shalt join thy praises with the Angels of peace, where sorrow and sighing shall eternally cease. And dwell with the saints & Angels above, In the beautiful city & arbor of love.

Around drum:
James Goodwin.

Beneath sword:
A faithful laborer in my holy vinyard, crowned with my glory.

D, RECTO:

The Word of the Holy Alpharine & Omega
To a Saint of his Eternal Glory.
Let the Heavens resound with praises, while from my Holy Throne, I view the redeemed of my glory, and everlasting love, who has walked in Wisdoms lovely paths, who has drank at the fountain of grief, and

bathed in the pool of sorrow, till his garments have become spotless, and his vestments white as purity, and are as gold, refined from all dross in my presence. Lovely and beautiful art thou to behold, O thou Prince of my Eternal Glory. Let thy spirit be merry within thee, Let thy hands be raised in praise, while thy feet step the time of sweet mirth, for surely thy God doth exalt and glorify thee, because of thy excellency, thy uprightness, thy holiness and purity. A man of Wisdom and child of God, upon whom I have placed my Anointing oil, and into whose hands I have given the keys of my Kingdom. Well done, my good and faithful servant, thou hast steadied my Ark in Wisdom, and done my holy will. Thou hast led on the armies of Israel, with my lighted lamps in thy hands, according to my pleasure, while from my Holy Throne I have viewed thee in praise and in love.

Around Ark:
The Ark of the Covenant
Blessed shalt thou be in thy out-goings, and in thy incomings, in thy basket [?] and in thy stores.

D, VERSO:

Every step that thou dost take, my blessing shall rest upon thee, while with my peace thy days on earth shall be crowned, and with my love shall they be enrobed. For surely I am that I am, a God of justice, mercy and love, who did look upon thee when young, with smiles of joy and pleasure, and did place upon thee the spirit of the spotless dove, by which the Angels in Heaven know thee, & praise and adore thee, because of thy lovely virtues. Therefore let thy spirit rejoice in me, thy Almight Creator, and march on thy way with joy and pleasure, until my time shall come, when I shall call thee home, to the mansions of my eternal glory, where thou shalt rest, crowned with my everlasting brightness, and enrobed with a garment of purity and holiness, sitting at the right hand of my Eternal Throne.

Below bird, left:
The Laws of Zion.
Altar

Below crown, center:
April 21st. 1844. Rufus Bishop.

Around bird, right:
The land of the Lord.
Desk.

In box:
Come thou & enter into the joy of thy Lord
For thou hast obey'd my All-righteous word
Hast kept my pure teaching my laws & com-
 mandments,
Which I have establish'd on Mount Zions land
Hast sounded my trumpet and gather'd my
 sheep,
And show'd them the waymarks wherein they
 must keep,
Hast taught them the word & will of the Lord,
So come and receive thy blessed reward.

In circle:
The Redeemed of my Eternal glory and
brightness.

BORDER:

There's beauty yet in heaven laid up, Be-
loved *ones* for thee Yea many blessings there's
in store For you dear Ministry.

This wreath was brought by Mother's
Little Dove for the Ministry at the City of
Peace, Dec. 4, 1853

CIRCLE:

1st Kind Ministry within this wreath,
 We place our Mother's love,
 'Twas her that bade us this prepare,
 And sent it, by her dove.

2nd So please accept our little store,
 Though small as it may seem,
 Yet we do feel a glowing zeal,
 The gospel's all our theme.

3rd Thy cries and tears ascend to Him,
 Who can all things control;
 But be ye patiently inclined,
 Though waves around you roll.

4th Think how thy blessed Mother stood
 Through tempest storm and flood,
 Vile persecutors raging sought,
 Her very heart strings blood.

5th Then look ye onward now my friends
 Though sorrows oft ye feel,
 We will with you through trials stand,
 And bid you comfort feel.

CENTER:

Written by an inspired Inst. Dec. 12,1853.
Farewell in love from Father James Father
Joseph Mother Lucy and Mother Dana.

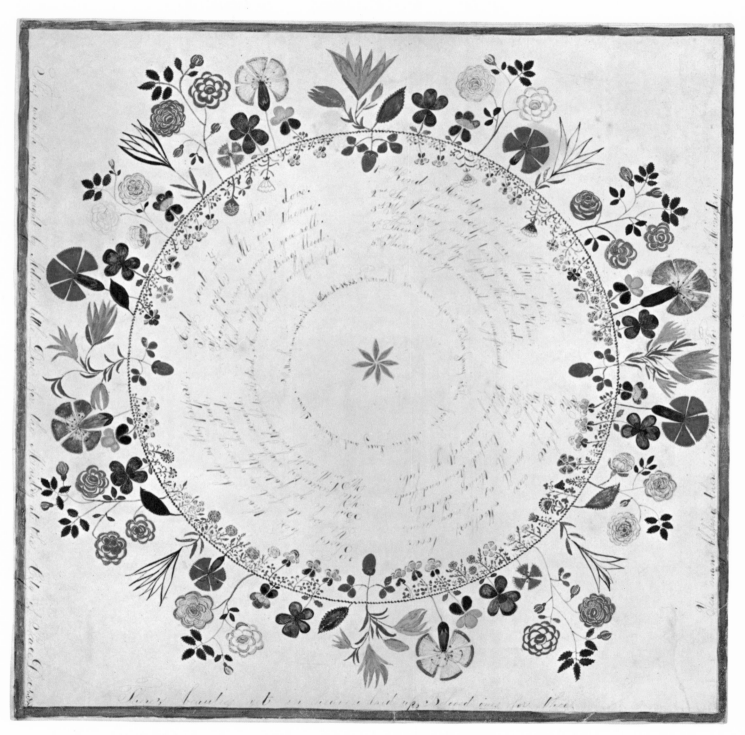

Plate III. Floral wreath. Hancock, 1853. Ink and water color; size: height, 12$\frac{1}{16}$″; width, 11$\frac{15}{16}$″. (Shaker Community, Inc.)

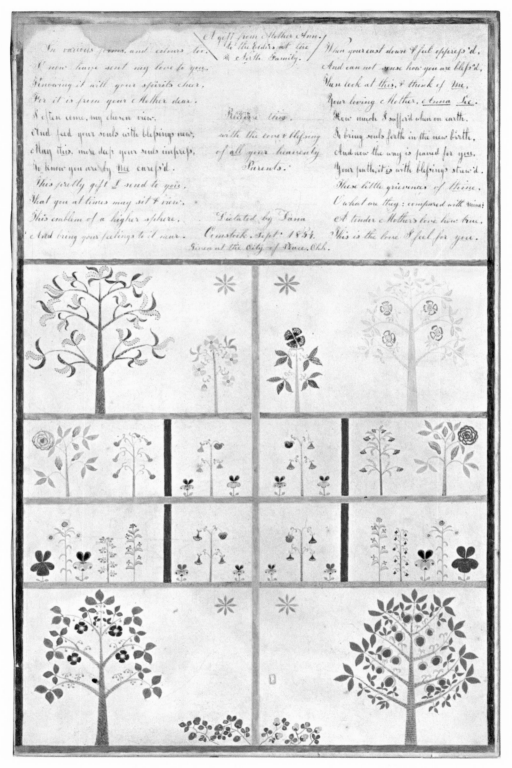

Plate IV. *A gift from Mother Ann to the Elders at the North Family.* Hancock, 1854. Ink and water color; size: height, 19″; width, 12″. (Shaker Community, Inc.)

LEFT:

In various forms, and colours too,
I now have sent my love to you,
Knowing it will your spirits cheer,
For it is from your Mother dear.
I often come, my chosen view,
And feed your souls with blessings new,
May this, more deep your souls impress,
To know you are by Me caress'd.
This pretty gift I send to you,
That you at times may sit & view,
This emblem of a higher sphere,
And bring your feeling to it near.

CENTER:

A gift from Mother Ann. to the Elders at
the North Family.
Receive this, with the love & blessing of
all your heavenly Parents.
Dictated by Dana Comstock. Sept 1854.
Given at the City of Peace. Chh.

RIGHT:

When your cast down & feel oppress'd,
And can not sense how you are bless'd,
Then look at this, & think of Me,
Your loving Mother, Anna Lee.
How much I suffer'd when on earth,
To bring souls forth in the new birth,
And now the way is paved for you,
Your path, it is with blessings strew'd.
These little grievences of thine,
O what are they; compared with Mine;
A tender Mother's love how true,
This is the love I feel for you.

from the gift songs, the numerous revelations and prophecies, the testimonies of departed Believers, the messages in which services are recognized and rewards promised, and the communications bearing on the secular life of the society.

The instruments ascribed most of the messages to "Our Eternal Parents" (Almighty God and Holy Mother Wisdom), "Our Heavenly Parents" (Christ the Saviour and Mother Ann), and "Our Spiritual Parents" (denoting the parents in "church relation," such as Father Joseph, Father James, and Father William). The first leaders at Hancock, Massachusetts, Father Calvin Harlow and Mother Sarah Harrison, revealed themselves to the instruments of that community. Word was also received from John the Revelator, the Apostle James, and the prophets Samuel, Elijah, Jeremiah, Malachi, Ezekiel, Daniel, and Esdras. The prophetess Deborah appeared on several occasions. Often the communications were borne by angels: the Angel Wisdom, the Sounding Angel, the Angel Gabriel, the Angel of Love, the Angel of Mercy and Judgment, the Angel of the Lord, the Roaring Angel, the Angel of Consuming Fire, and the Holy Witnessing Angel of God. Once, the words of the God of power, light, and love were heard from the eternal fountain in the city of brightness. The communications were patterned in diction and sentiment after scriptural models and were often transmitted on scrolls.

Cast in this peculiar message form was the plea, familiar to revivals, for the people to rededicate their lives to the pure service of God. The Shakers were reminded of their early covenant, of the lofty principles on which the society had been founded, and of the sacrifices involved in consecration. Without the inspiring personal influence of Mother Ann and the first leaders, departures from original standards were inevitable. Material prosperity was attended by worldly temptations. Contact with the world bred an impatience with traditional disciplines, especially among the young. The line once carefully drawn between the world of generation and a regenerate order was becoming blurred, and dreaded signs of conflict and disunion were appearing. The spiritual movement beginning in 1837 took the direction of reawakening the consciousness of separateness, of reestablishing distinctions between the chosen of God and the Children of Adam.

The following excerpt from an exhortation, delivered to the young in the Second Order of the New Lebanon Church by the instrument Giles B. Avery, is

characteristic, both in its prevailing sentiment and in its use of metaphor and Biblical diction:

Drink dry your cups of repentance; and the heavenly graces shall glow in your souls. Work, work, dearly beloved, gather the fruits of the vineyard of the Lord, for the time surely cometh when you will be called to administer to those who now stand without, waiting to be bidden. Yea, trade ye with the tallents received, for the Lord requireth his own with usury.

Delay no longer, cast out the evil weeds; prune the supplient vine, and cultivate the plants of love, meekness and true charity; then shall you be your Lord's delight and Mother's pleasure.[25]

Such writings greatly influenced the life and thought of the sect. The authority of the instruments gradually increased until the messages, at one time confined to spiritual matters, included directions on the management of the temporal affairs of the community. Brother Philemon Stewart set the example in the "Holy Laws of Zion" (1840), which proposed a thorough revision of the regulations of the sect in the interests of purity, simplicity, and humility. Departures from early ideals were condemned, proposals were made to restore trades that had been abandoned, and hired labor was decried as a violation of a sacred principle.

Certain declarations bearing on the responsibilities of leaders and the correct behavior of members were incorporated into the Millennial Laws of 1845, a code of gospel statues, which had been slowly developing from the first oral rules and orders of Father Joseph Meacham.

The Shaker central ministry at New Lebanon, composed of two elders and two eldresses, did not at first greatly restrict the activities of the instruments; members of the "lead" often came under the influence themselves. However, the communications, especially those dealing with the temporal affairs of the society, needed to be carefully examined and false testimony to be separated from the true. That the ministry continued to believe in the practical utility as well as in the divine source of communications is evidenced by their agreement to the publication in 1849 of Paulina Bates's *Divine Book of Holy Wisdom*. Inspired messages were regularly committed to manuscript until 1855 and after, and the

[25] Father James, "An address to the young," in Giles B. Avery, "A true record of sacred communications; written by divine inspiration; by the mortal hands of chosen instruments; in the church at New Lebanon," New Lebanon, [N.Y.], 1841.

editors of the fourth edition of *The testimony of Christ's second appearing* (Albany, 1856)[26] reported that "special inspired gifts have not ceased, but still continue among this people."

In two important respects the messages are related to the graphic expressions of Shaker inspiration. First, communications and songs, like the drawings, were commonly presented to particular recipients as gifts or rewards. Thus, in "A Record of Messages and Communications Given by Divine Inspiration in the Second family, City of Peace," letters are addressed to members designated by initials only: for example, E. W., J. C., A. R., R. H., and L. M., Nathaniel Deming, who led the Hancock society for fifty years after the death of Father Calvin Harlow, and Grove Wright, his successor in the ministry, possessed manuscript books of personal messages. In each book is "A pretty and comforting Reward. Holy Mother's Testament Written by God. In the english tongue, bound and sealed, by the Holy Angel of the Lord. 1842," a communication in three chapters, the spirit and function of which are identical with those of both the reward songs and the heart and leaf rewards drawn about two years later.

Similar gifts to individuals sometimes were in the form of small booklets neatly bound in paper and carefully written. More often, single sheets of white or tinted paper were used and called cards of love, notices, precious sheets, tables of record, tickets, or presents. A typical example of the booklet-gift contained the "Words of a Shining Roll, Sent from Holy Mother Wisdom to Brother Rufus Bishop. July 10th, 1842. Copied from the Original, August 16th, 1842." The message covered twenty-one pages of pink paper (3 by 4 inches) and was bound in a gray-blue cover inscribed with the name of Brother Rufus Bishop. On a wrapper of darker blue were affixed "R. B." seals. A commoner form of the brief token message was the card of love, a sheet of white, pink, rose, blue, or yellow paper, usually measuring about 5 by 8 inches, double margined, and neatly inscribed on both sides. In rare instances such documents were decorated with a conventional floral design.

Second, the images and symbols constantly employed in the messages often appear in the drawings. The following records of emblematic gifts, mostly received in 1841–44, indicate the material available to the artists of the next few years:

[26] The standard work on Shaker theology, sometimes called the Shaker Bible; first published in Lebanon, Ohio, in 1808.

1. From "A Record of Messages and Communications given by Divine Inspiration in the Second Family, at Pittsfield": the trumpet of life, which "rouses to a living sense . . . the lost fallen state from God"; the trumpet of conviction, the gospel trumpet, the trumpet of repentance, trumpets of terror; a girdle, a "white flag of peace," a "tabret of love," "a stout and ruddy heart," a diamond of charity, a chrysolite, a chalcedony, an emerald, a sapphire, a jacinth, a topaz, an amethyst, a sycamore, an olive, a colocynth, and "a branch of holiness from my vineyard"; a holy musical instrument of God and harps of love; rolls of paper or parchment "taken from a box"; sweet scented manna on shining plates; a cake of love; four baskets, one filled with trumpets on which were written "the voice of heaven," another filled with jewels of simplicity and strength, another holding a gold box filled with rings for the fingers "to feel the word of God," and the last filled with pearls of charity; gold censers filled with the power of the living God, Mother's eternal truth, the fire of Zion, and rods of correction; a bright cross and sharp swords.

2. From an untitled book of messages at Hancock, Massachusetts: bright pieces of gold, a gold plate, plates of wisdom, a "golden bowl of brightness . . . filled out of the never failing fountain with the richeness of heaven"; a band of brightness; a ball of promises; a heavenly dove "meek and mild"; a very large ship representing Ease and Pleasure; "very pretty spiritual buildings."

3. From "A Record of Communications from the Spiritual World to Grove Wright, Hancock": a golden candlestick; a sheet of pure gold; a large silver cup "filled with holy and pure love right from Christ and Mother"; leaves of a pure white lily; pearls of heavenly beauty; a fan of eternal truth; a bright rod of comfort; a heavenly dove; a ball of love; trees of life; a leaf from the tree of life; a leaf of love inscribed with verse; red seals.

4. From "A Record of Communications from the Spiritual World for Albert Battles. Given by divine inspiration, First family, city of love, Jan. 10th, 1841": a gold leaf inscribed with words of comfort; a golden trumpet inscribed; the wings of a dove appropriately inscribed; a grapevine; "obedient lambs of the fold, who have never strayed from my pastures of protection"; a ball of love; a leaf of the tree of life.

5. From "A Record of Communications from the Spiritual World to Elder Nathaniel Deming": the pleasant groves of heaven, silver cups, and a censer of gold; leaves and balls of pure love.

TOP, LEFT TO RIGHT:

Upper left, below dove:

Behold saith the Lord, I will gather from the four quarters of the earth many souls, and they shall sit down in my Kingdom of Peace, and the babes of my pleasure shall feed them.

Dove's message:
A Song of Peace.

Below watch and chain:

Come gather from my Tree of Life sweet fruit, and eat in remembrance of Me your Mother, when your soul is weighed down with deep tribulation and sorrow.

Left of large lamp:

Receive this Lamp from me, says Father William, and remember Christ's word to the good Sameritan.

Over trees beside beehive:
Plumb Tree. Tree of Life.

CENTER, LEFT TO RIGHT:

On tree, left:
Fruit of Purity.
Fruit of Selfdenial
Oranges.
Basket & balls of Love
Peaches.
Cherries.
An Instrument of music From Father James.

Large plant in center of drawing:
A Holy Plant, And fruits of Faith.

In open book. Mother Ann's words to Mary Hazard:

I will be unto thee a Parent and thou shalt be my child says Mother: for thy offerings ascend to my Throne without spot or blemish. Therefore let thy heart rejoice, and thy tongue sound forth praises to God, while you view and review the choice treasure I have selected and bro't unto you from Heavens bountiful stores. I will daily send my ministering doves to watch over you & protect you from all harm, says your loving Mother Ann.

Plant and flowers, right:
Fair flowers from Heaven above Union S-i-m-plic-i-t-y. Love.

BOTTOM, LEFT TO RIGHT:

Plate of Cake.
Table of Wine.

Above table of wine:
A Present from Mother Ann to Mary H. Nov 29th 1848.

In heart:

Blessed are they whose hearts are steadfastly set heavenward. Like the evergreen they shall flourish in the sight of the Lord.

Above figure in airship:

With my shrill sounding Clarion I will fly thro' the Nations & sound an alarm.

Legend on flag:
Freedom.

Above semidarkened moon, to left and to right:

Hear me my child says Mother, while I speak unto you Tho' thy sun may appear to be going down at noon, and the moon cease to give light, yet with an outstretched arm and protecting hand, I will guide you safely thro the dark wilderness of time. Trim up your lamp and hasten on, and I will lead you to that bright world, where sorrow troubleth not the righteous

Under star, or medallion, bottom, left:

The path to my Kingdom, is pleasant and sure,
Be faithful my child, all trials to endure.

Under star, bottom, right:

I'll watch you by day, Ill guard you by night,
I'll make you a star, to shine clear and bright

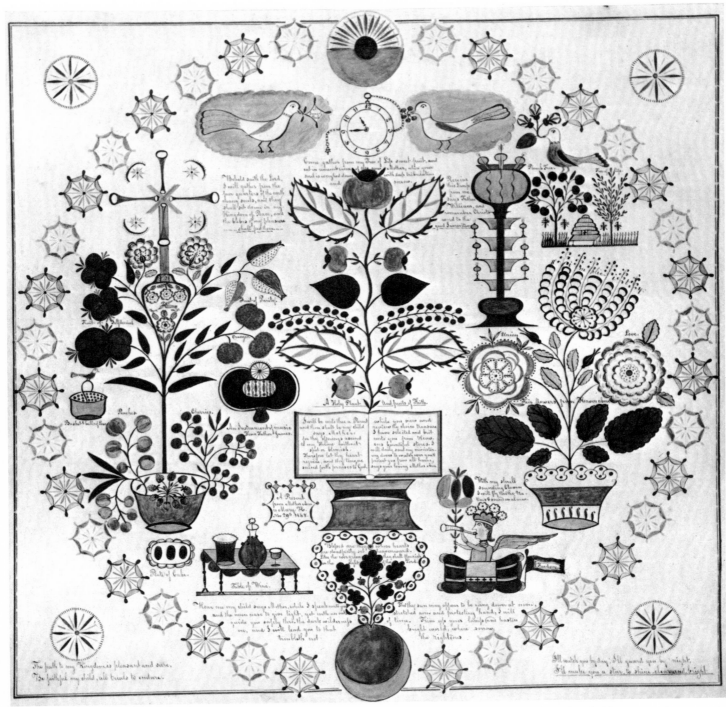

Fig. 7. *A Present from Mother Ann to Mary H.* New Lebanon, 1848. Multicolors with indigo blue predominating, on pale-blue paper; size: height, 14″; width, 14¼″. (The Abby Aldrich Rockefeller Folk Art Collection, Williamsburg, Va.)

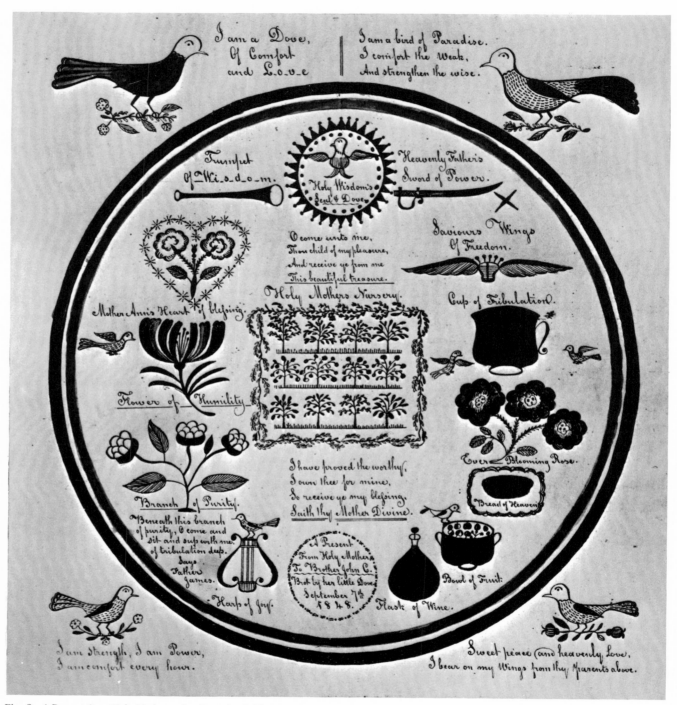

Fig. 8. *A Present from Holy Mother to Brother John C.* Place unknown, 1848. Ink and water color; size: height, 7¾″; width, 7⅜″. (Courtesy of The Western Reserve Historical Society.)

Top, left and right:

I am a Dove,
Of Comfort
and L-o-v-e
I am a bird of Paradise.
I comfort the Weak,
And strengthen the wise.

Within circle, left, top to bottom:

Trumpet of W-i-s-d-o-m.
Mother Ann's Heart of blessing.
Flower of Humility
Branch of Purity.
Beneath this branch of purity, O come and
sit and sup with me, of tribulation deep. Says
Father James.
Harp of Joy.

Within circle, center, top to bottom:

Holy Wisdom's Seal & Dove

O come unto me,
Thou child of my pleasure,
And receive ye from me
This beautiful treasure.

Holy Mothers Nursery.

I have proved thee worthy,
I own thee for mine,
So receive ye my blessing,
Saith thy Mother Divine.

A Present From Holy Mother, To Brother
John C. Brot by her little Dove. September
7th 1848.

Within circle, right, top to bottom:

Heavenly Father's Sword of Power.
Saviours Wings of Freedom.
Cup of Tribulation.
Ever-Blooming Rose.
Bread of Heaven
Bowl of Fruit.
Flask of Wine.

Bottom, left and right:

I am Strength, I am Power,
I am comfort every hour.
Sweet peace and heavenly Love,
I bear on my Wings from thy parents above.

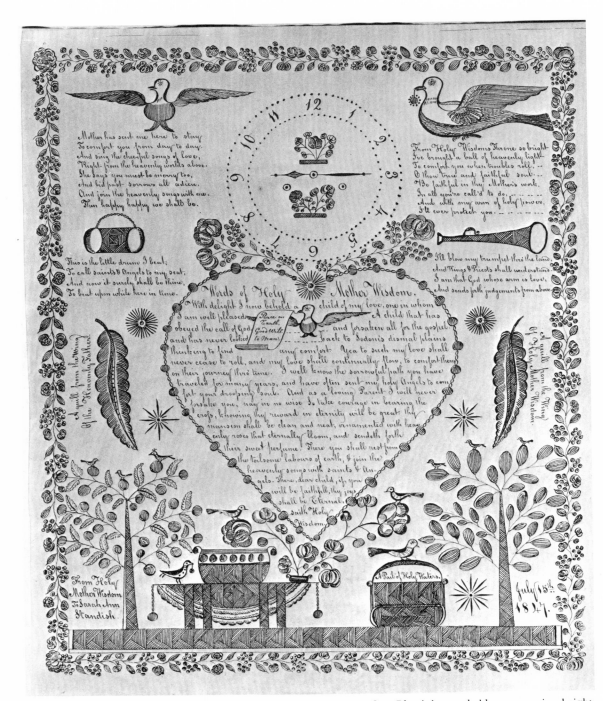

Fig. 9. *From Holy Mother Wisdom to Sarah Ann Standish.* New Lebanon, 1847. Blue ink on pale-blue paper; size: height, 9¹³⁄₁₆″; width, 7⅞″. (Shaker Community, Inc.; photograph, Geoffrey Clements.)

TOP, LEFT:

Mother has sent my here to stay
To comfort you from day to day.
And sing the cheerful songs of love,
Right from the heavenly worlds above,
She says you must be merry too,
And bid past sorrows all adieu.
And join the heavenly songs with me,
Then happy happy we shall be.

Below drum:

This is the little drum I beat,
To call saints & Angels to my seat,
And now it surely shall be thine,
To beat upon while here in time.

TOP, RIGHT:

From Holy Wisdoms Throne so bright
I've brought a ball of heavenly light
To comfort you when troubles roll,
O thou true and faithful soul.
Be faithful in thy Mother's work,
In all you're call'd to do,
And with my arm of holy power,
I'll ever protect you.

Below trumpet:

I'll blow my trumpet thro' the land,
And Kings & Priests shall understand.
I am that God whose arm is love,
And sends forth judgements from above.

CENTER:

Left of heart:
A quill from the Wing Of the Heavenly Father.

Right of heart:
A quill from the Wing Of Holy Mother Wisdom.

Within heart:
Words of Holy Mother Wisdom.
With delight I now behold a child of my love, one in whom I am well pleased. A child that has obeyed the call of God, and forsaken all for the gospel. and has never looked back to Sodom's dismal plains thinking to find any comfort. Yea to such my love shall never cease to roll, and my love shall continually flow, to comfort them on their journey thro' time. I well know the sorrowful path you have traveled for many years, and have often sent my holy Angels to comfort your drooping soul. And as a loving Parent I will never forsake you, nay in no wise So take courage in bearing the cross, knowing thy reward in eternity will be great: thy mansion shall be clean and neat, ornamented with heavenly roses that eternally bloom, and sendeth forth their sweet perfume. There you shall rest from the toilsome labours of earth, & join the heavenly songs with saints & Angels. There, dear child, if you will be faithfull, thy joys shall be Eternal, saith Holy Wisdom.

In beak of dove:
Peace on Earth, Good Will to Man.

BOTTOM, LEFT TO RIGHT:

From Holy Mother Wisdom To Sarah Ann Standish.
A Pail of Holy Waters.
July 15th 1847.

6. New Lebanon inspirational message, 1841: trumpets; balls of love "to put into these trumpets so that when blown, the messages of love will scatter"; cups of balsam; robes of love, meekness, and purity "bordered with pure gold"; belts of wisdom; chains of pure gold.

These messages, it will be noted, occasionally refer to the tree of life, which was to become a favorite subject of the drawings. The significance of this figure is clarified by the following excerpts from two messages received from the spirit of Father James at New Lebanon in 1841:

Lifeless, stupid and disbelieving souls, are not joined to the tree of life; neither can they receive nourishment from the true vine. . . . I wish you all to remember that the beautiful tree which I saw in vision . . . is now planted in this land, to grow and increase, and bring forth fruit acceptable to God. . . . The glory; order and beauty of this tree, (which resembled the Church of Christ complete) was so great that the very leaves thereof, even to the utmost extremity of the branches, appeared like blazing torches [Plate I].

The visionary messages and testimonies of the period abound with imaginative details of the beauty of unworldly scenes:

His mansion . . . was lined with gold and set with glittering diamonds. ["Eliab Harlow's entrance into the Heavenly world." New Lebanon visionary message, *ca.* 1840.]

The garments of this Angel were red, & of the deepest hue. The writing upon the wing had the appearance of color of gold. The left wing was black and folded most of the time, and above his head was a large red ball, some resembling fire. [Canterbury visionary message, 1845.]

I saw a company of Angels descending, it appeared from extreme heights in the west. . . . They carried between them a long vessel, having on each side an hundred handles, which were grasped by the first Angel of each rank, and thus the vessel was carried along. Upon the top of the vessel burned brightly an hundred lamps. [Canterbury visionary message, 1845.]

The diverse nature as well as the source of the visionary gifts is revealed by a single-page document prepared at New Lebanon about 1848 and entitled "Some Beautiful Presents received at different times from our Heavenly Parents":

From Mother Ann:
By the hands of a little Squaw
a white Robe folded and placed
in a Glas Box.

From Mother Ann:
A Pail blue silk handkerchief with
a white fringe, & a little song book.

From Mother Lucy:
A beautiful little Branch with a little
Singing Bird of several collors with a song
in its mouth, a little Star to put on my
forehead.

From Mother Ann:
A little Bag of Gold Cross and a
little Gold Hatchet to kill old ugly[27]
with.

From Mother Ann:
Sixty one thousand six hundred
and six gold dollars.

Another communication is arranged around a central square in which are three concentric circles of writing. The outer circle is formed by the words "And blessed Father William And all my heavenly Parents I love to sound the name of my blessed Mother Ann." Bordering this sentiment are the letter notes of early Shaker music. The next circle is formed by the words "This little song was placed on a very little Harp about two inches long and given to Mary Hazard." The inner circle is made up of the inscription "From Mother Lucy with her Kind love and blessing. November 1st." In the center of this circle is the date 1843, surrounded by the word "HARP."

One other document illustrates the curious forms of certain spiritual gifts. This is "A Precious Little Sheet of Spiritual Presents," a folder of white paper measuring 4 by 7 inches and signed by Mary Hazard of New Lebanon:

A Present from br Seth Y. Wells, to br Isaac Youngs, to divide with all the Brethren and Sisters, under the age of 60 down to 30 it is *5000 lb of GOLD*. . . .

. . . and on it all is written,
Spend not the durable riches for that which passeth away and is no more. . . .

The value of the 5000 lb of Gold, is one million one hundred and twenty five thousand dollars, (as we recon) & that is twenty three thousand, four hundred & thirty seven dollars and fifty cents to each person.

MARY HAZARD.

As has been indicated, there was a close relationship in spirit and content between such messages and the inspired drawings. One kind of gift was ornamented with figures of speech, the other, with graphic emblems.

[27] "Old Ugly" and the "Old Deceiver" were Shaker names for the Devil.

II. *Shaker Religious Art*

THE Era of Manifestations, from 1842 to 1845, was the time when inspiration first found outlet in pictorial form, in cards of love and the cryptic drawings which the Shakers called sacred sheets. Later leaf and heart rewards were cut from colored paper and inscribed with messages and simple symbols. By 1843 such gifts, or tokens, must have been common, for Isaac Youngs in his "Concise view" refers to them in the only comment from a Shaker source: "There have been many notices to individuals, this year past, as well as before, in writing, with many drawings, signs and figures of objects in the spirit world, with mysterious writings, etc. which will, it is said, at some future time be revealed & explained." [1]

Few if any major drawings and paintings were produced before 1845, the date of "The Tree of Light or Blazing Tree" (Plate I), a gift "From Holy Mother Wisdom to Eliza Sharp" (Fig. 10), a gift "From Father Joseph, to Eliza-Ann Taylor" (Fig. 18), and a symbolic message "From Holy Mother Wisdom to Hannah Ann Treadway." Also, except for "A Cedar of Paradise" (Watervliet, 1846), no major drawings were again produced until 1847; by that time the spirits had departed, the mountain festivals had been discontinued, rituals were becoming less spirited, and the manifestations in general had lost some of their fervor. From 1847 to about 1859, however, these pictorial documents were an increasingly popular channel of expression. With content taken from the songs, messages, and inspirational experiences of the preceding years, they seem to be the products of a calmer mood, the recording of emotions "recollected in tranquillity."

To Youngs, these pictures were inexplicable. At once primitive and complex, naive and ingenious, they are subject to varied interpretation. Did they have

[1] Youngs.

some utilitarian purpose, or were they an end in themselves? Were they actually spirit drawings, the product of supernatural agencies? Or were they the expression of an inner force released by the revival? In an order opposed not only to decoration but also to superfluity of any kind,[2] how was it that they came into being at all, and why were they sanctioned?

Eldresses Anna White and Leila Taylor, Shaker historians who believed in supernal presences, inclined to the view that gifts were employed by the spirits of Mother Ann, the first witnesses, and other religious teachers for educational purposes. These spirits made use of the object-lesson methods of the Froebelians, then in vogue, to illustrate ideas, at first with simple, and then with more complex, materials. "Simple deductive reasoning first," the eldresses explained, "abstract thought and broader, advanced deductions later, with simplicity, receptivity, obedience, humility and teachableness as the necessary foundation for true spiritual education, seems to have been the plan of development of these unseen teachers."[3]

The eldresses made no direct reference to the drawings. Other gifts, however —the figurative presents which accompanied and illustrated these compositions; the songs, messages, and symbolic gifts presented to the worshipers on the holy mounts; the Christmas meeting—may have been used by the instruments, in obedience to the "lead," for the express purpose of impressing and encouraging and otherwise educating the rank and file. In one mountain meeting, for example, the Saviour, speaking through the Hancock instrument Joseph Wicker, says: "I would instruct those that do not clearly understand the work of God, I work by means and ways that ye may understand, comparing heavenly and divine things to the simmilitudes of earth." And again: "Dear children, I instruct you both by signs and symbols, I speak in a manner that ye can understand."

In a passage from "A Closing Roll from Holy and Eternal Wisdom" the instrument Philemon Stewart further clarifies the purpose of spiritual gifts:

All the presents that I have sent, or caused to be sent forth unto you, must be used in a proper line of sensation, for they are all spiritual, whether they be from those of ancient or modern date. They have been sent forth in this degree of nearness and semblance of material things that do

[2] On the subject of wall decoration, the "Millennial Laws, or Gospel Statutes and Ordinances," as revised in 1845, warned the members of the society that "no pictures or paintings shall ever be hung up in your dwelling rooms, shops or office."

[3] *Shakerism: its meaning and message* (Columbus, Ohio, 1905), p. 235. The peculiar inspirational gifts are compared to "kindergarten work in modern educational methods."

TOP:

This Tree was drawn in the year 1855.*
The following lines were written by Elder Brother Joseph Wicker's moving the hand of the writer. Dec. 2nd 1855.

Left and right of tree:

Firstly, J. W. is here he is guiding you, Secondly, There are four Angels who are guarding this tree, and it increases in beauty as ye increase in goodness. The offerings of the faithful are placed upon a table under it, and nothing but pure good treasures are placed thereon; thereof ye may all partake that are worthy. And none else can or may partake, so saith the spirits.

BOTTOM:

Left and right of tree:

The four and twenty Elders many times assemble under the branches of this beautiful tree.
This heavenly Tree standeth in the center

The design was perhaps inspired by the tree of life in Revelations, "which bare twelve manner of fruits."

of the meeting room in the Church. City of Peace.
It is in union with the Heavenly Father that this is now brought to view; And holy holy Mother hath sent it unto you.
It is called by the spirits The Gospel Union, fruit bearing Tree.

1st In holy love she leadeth you
 Through grief and sorrows deep;
 And of her beauties you will view,
 From her rich store you'll reap.

2nd My dear beloved care-worn friends,
 I now bring to your view;
 A faint resemblance of that home
 That Mother giveth you.

3rd Beloved ones, when this you see,
 Know ye there is a place;
 When from Earth's sorrows you're set
 free
 To join the heavenly race.

4th Receive ye now the holy love,
 Of all those Angels' light;
 Whose watchful eye will always keep
 This fruit shall never blight.

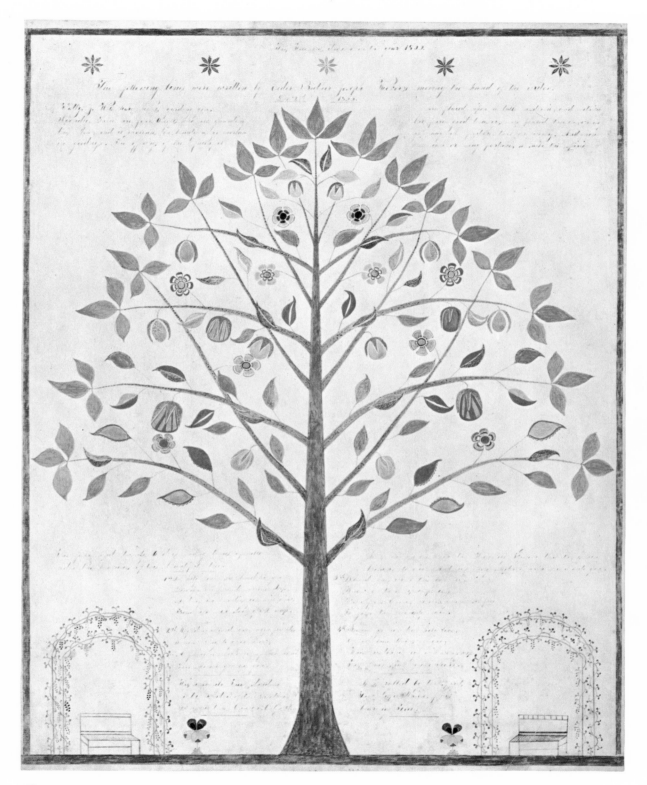

Plate V. Heavenly tree. Hancock, 1855. Ink and water color; size: height, 23⁵/₁₆″; width, 18¹/₈″. (Shaker Community, Inc.)

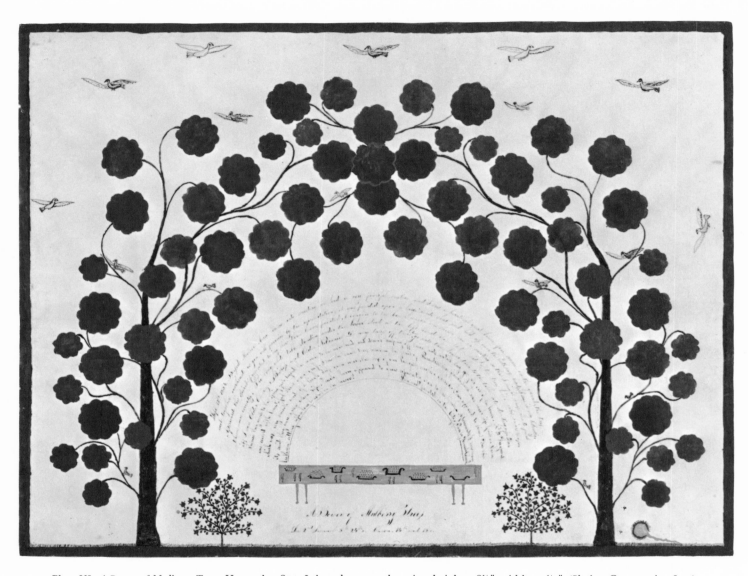

Plate VI. *A Bower of Mulberry Trees.* Hancock, 1854. Ink and water color; size: height, 18⅛″; width, 23¹/₁₆″. (Shaker Community, Inc.)

Sept. 13th 1854. Blessed Mother Ann came into meeting we had a very powerful meeting and I saw a beautiful great bower four square on the ground; the trees met together overhead as you will preceive by the representation; it was painted upon a large white sheet and held up over the brethrens heads, I saw it very distinctly. Afterward the spirit presented to my view three leaves painted, belonging to the bower which was shown me in meeting so that I might know how to paint them more correctly. The long white table standing under the bower stood at the left hand close by the side of the trees with cakes knives etc. upon it; I saw Elder Ebenezer Bishop and Elder Nathaniel Deming take off their hats go into the bower then to the table ate standing up. Then thence they went to the spring just beyond the square to the right hand and drank keeping off their hats, untill they got fully out of the bower. N. B. The ground was cover'd with beautiful short green grass; I saw the small trees bearing the fruit of Paradise very plainly, there was much ripe fruit on them which was very smooth and of a lively deep green color, the size of our largest english cherries. (They appeared to shine) The spirits said they were green when ripe, each berry appeared to grow separately close to the limbs — Afterwards I saw many brethren sitting upon long benches in the bower. Seen and painted in the City of Peace by Hannah Cohoon.

A Bower of Mulberry Trees

See 2nd Samuel. 5th 24th. v. Chron. 14th and 15 v.

exist on earth, that you might be better able to appreciate in lively colors, and thrilling sensa-
tions, the real adornings and beauties of the spiritual world, or the abodes of the righteous,
in the paradise of God, of which the earth and all the arts of man's invention are but a dismal,
gloomy and imperfect figure.

Therefore make no mention, in common and passing talk, of these rich presents which have
been sent unto you; but with all these things you may be rejoiced in lovely smiles of the solemn
fear of God. And they will be a great help to you, if rightly used, in keeping your sensation in
that line, that it will be easy for you to get hold of the gifts of God, when you assemble to worship
him.[4]

In their allusions to signs, symbols, and semblances these spokesmen for the
sect may have had the drawings as well as other gifts in mind. But though the
cards of love, sacred sheets, hearts, leaves, and more elaborate inspirationals
were dedicated to, and in some cases presented as gifts to, certain members of
the society—as tokens of gratitude or rewards for good work—they were never
circulated or displayed and therefore served no communal educative purpose.
The heart and leaf tokens may have been keepsakes, but the larger pictures were
apparently never bestowed as permanent possessions: "those blessed gifts,"
according to one message, "manifested through this one and that, are not their
own." Besides, the ownership or display of such treasures by an individual would
have violated the communal laws. Since it was contrary to order to hang up
charts, pictures, or paintings, it is probable that such objects of fancy remained
in the custody of the presiding ministry or family elders.[5]

Secrecy extended to authorship. So quietly were the drawings done that few
Believers after the period of the great revival knew that they existed. They were
usually unsigned, in obedience to the millennial law that forbade any one to
"write or print his name on any article of manufacture, that others may here-
after know the work of his hand." Humility was held in highest esteem: heavenly
gifts, as the author of "The Sacred Roll" warned, were to be revealed "not through
vessels polished by the arts and sciences, cultivated by man, but through such as
are humble and dependent children, who seek to know, and do God's will, as
the first, and greatest object of their pursuit; who dwell in a humble and se-

[4] Canterbury, [N.H.], 1843, p. 23.

[5] Many of them, it seems, were subsequently
destroyed by their custodians, who feared they
might be misunderstood or ridiculed. But as
Hervey Elkins wrote, "The Shakers, needlessly,

fear to have the whole truth known concerning
them by the world. In some respects, they, there-
fore, try to evade it. Their plea is, that 'the natural
man cannot discern the things of the spirit . . .'"
(Elkins, p. 103).

cluded position in life." Even in the hymnals the names of the instruments who received the words and music, though originally inscribed at the end of the song, were subsequently erased so that certain members of the society would not appear to be especially privileged to communicate or receive such gifts of God. "Speak but little about your spiritual gifts," said a message from Mother Ann in 1841; "you may simply speak before those who are weak in faith, and they may take a wrong understanding, and do hurt with those beautiful gifts I have given you for your comfort and encouragement in the way of God."

In view of the restricted use of the drawings and the secrecy surrounding what probably was a limited production, one must conclude that the more elaborate ones at least were not an important means of educating the Shakers in spiritual realities.

The next question is whether the drawings should be interpreted in terms of the supernatural, as the work of some mysterious external agency, which their creators were powerless to control. The Shakers themselves, as heirs to the mysticism of the French Prophets and other inspired sects, were at first ready, in fact, almost eager, to ascribe their gifts and revelations to discarnate agencies. In their revival meetings they entered into trances, during which they saw visions, heard songs, and gave way to uncontrollable impulses. "Under operations" instruments proclaimed that they spoke in the name of Jehovah, Mother Ann, or Father James; that the Saviour had given them a message; that some departed saint or a tribe of Indians seeking the true gospel was really in their midst. It was inevitable therefore that strange myths should arise, false testimonies be circulated, and convictions of metaphysical causation be fostered. This belief in an external authorship was reinforced in the minds of the credulous. The drawings were compared with the "spirit drawings" which emanated from the school of "modern" spiritualism, a movement which, according to Wilkinson, directly followed the Shaker manifestations.[6] There were accounts of visions, which sometimes found expression in automatic drawings: "primitive designs of angels"; spirit emblems such as stars, circles, feathers, and wings; flowers of no

[6] W. M. Wilkinson, *Spirit drawings: A personal narrative* (London, 1858). (See bibliography.) Such an eminent authority on modern spiritualism as Podmore was convinced that the communications received by the Shakers "had little in common with the Spiritualistic manifestations which they were supposed to foreshadow" (Frank Podmore, *Modern spiritualism. A history and a criticism*, London, 1902, p. 209). Youngs himself wrote in 1850 that the spiritualistic phenomenon heralded by the rappings of the Fox sisters in Rochester (1848) was a form of communion with the spirit which was "not for Believers in our faith."

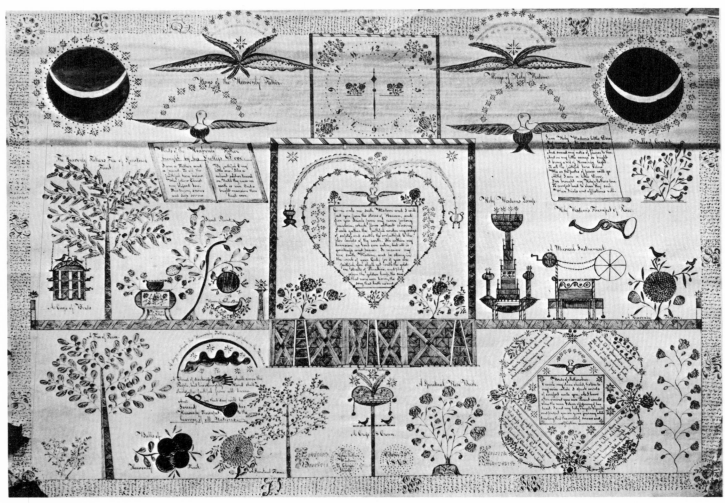

Fig. 10. *From Holy Mother Wisdom to Eliza Sharp.* New Lebanon (?), 1845. Blue and red ink on white paper; size: height, 14¾″; width, 20¾″. (Courtesy of The Western Reserve Historical Society.)

Wings of the Heavenly Father.

In book beneath dove:
Words of the Heavenly Father, brought by
his Spotless Dove.

I am a Father and a friend, To all the
faithful here below, Who follow Christ my
blessed Son, Thro' trying scenes and deep
sorrow. Be faithful O my little one, Like a
valient soldier travel on, Until thy race on
earth is run, And a bright mansion thou has
won.
The Heavenly Fathers Tree of Spiritual
Fruit.
Bread Plant.
A Cage of Birds.
The Heavenly Fathers Altar.
Heavenly Fathers Dove
A Tree of Peace.
A Sign which the Heavenly Father will yet
place in the Heavens.

Beneath cloud:
A Cloud of darkness shall cover the People,
but his Almighty Hand shall shield the faith-
ful from all harm. And in that day will he
Sound his Heavenly Trumpet, to the hearing
of all Nations.
Balls of Heavenly Fruit.
A Spiritual Flower.

In heart:
Come unto me saith Wisdom and I will
feed you from the stores of Heaven, and
give you drink from my never failing foun-
tain, which flows without ceasing. I will
gather the faithful under my wings of safety,
and scatter the unfaithful to the four winds of
the earth. For within my mansion no evil
can enter, but all is quietness and peace. So
receive my love saith Wisdom, and be strong
in the work of your God; for if you are faith-
ful, you shall yet walk the golden streets of
Paradise, and play upon the golden harp, the
song that none can learn, the song that hath
no end.
Feathers of Victory
A Spiritual Rose Bush.
A Cross & Crown.
From Holy Mother Wisdom To Eliza
Sharp October 25th 1845.

Wings of Holy Wisdom.

In scroll held by dove:
I am Holy Wisdom's little Dove.
My name is Si ne an sa ve;
I sit on the branches of pure love,
And sound my notes of praise to thee.
And on my little wings so bright
I bring a roll of Heavenly light;
To all the faithful here below,
Who in the paths of peace will go.
Altho' I am a little Dove,
I've brought my Holy Mothers love.
To comfort and to cheer thy soul,
When trials and afflictions roll.

Balls of Comfort.
Holy Wisdoms Lamp.
Holy Wisdom's Trumpet of Peace.
A Musical Instrument.
A Heavenly Flower.

Four-cornered figure, clockwise, starting with left corner:

Tis here with Mother I will send
My love to you which hath no end
And ever will remain your friend
William Lee.

Receive my love says Father James.
And let it strengthen you.
For Lo I see the narrow path,
Thy soul will yet pass thro'.

Receive my love dear child,
And on it take delight.
And know it is right from,
Your loving Mother Lucy Wright.

I'm Father Joseph whom ye well know
Did pass thro suffrings here below
And in obedience to God's will,
The Church of Christ I did rebuild.

Square in center:
Words of Mother Ann.
O Come my dear child, listen to my voice
while I speak words of comfort unto you. As
I have often viewed you as a Parent would
view the near & dear offspring of her heart.
I send my holy Angels to guard and protect
you on your journey while traveling thro'
this world of sorrow and affliction.

Wings of Holy Wisdom.
Sun
Words of Holy Wisdom. Brought by her
message bearing Dove
Thro' the heavens of heavens I fly with my wings loaded down with the blessings of God for thee my true & faithful child. So in thy Mother's love rejoice, and bid past sorrows adieu, and call thy little lambs to come to the fold of Zion, where they can drink from the living fountain of eternal goodness, saith Holy Wisdom.
Holy Wisdom's Dove
Holy Wisdom's Burning Lamp.
A Cage of Singing Birds From Holy Wisdom.
A message bearing Dove.
Holy Wisdom's Heavenly Dove.
From Holy Mother Wisdom To Daniel Boler
A Tree from Father William.
A Table of Fruit.

Center:

Within heart:
I am thy Mother, Holy and Eternal Wisdom, my spirit breatheth peace on earth and good will to man; I delight in the pure in heart & the lowly in mind; unto such my blessing shall never cease to flow. I will clothe them with my mantle, a white and seamless robe, I'll crown them with salvation when they enter the city of their God, the mansions of the righteous, with Holy and Eternal W.i.s.d.o.m.
Peace be unto the righteous

Beneath square:
A Sword.
A Harp
A Trumpet
A Table of Shew bread
A Holy Altar

Right, top to bottom:

Wings of the Heavenly Father.
Moon
The Words of the Lord. Brought by his message bearing dove.

O Zion, Zion, thou people of my name, how long have my holy Angels sounded their trumpets of freedom and daily fed thee from my stores of choice treasures, till ye were full to overflowing.

O treasure up those heavenly things
And to thy soul t'will comfort bring.
For thro' much suffrings you will go,
Before you leave this vale below.

The Heavenly Father's Dove

Come tune thy harp, thou brave & strong.
Invite the heavenly hosts along,
To praise and worship God above,
Who has sent to thee his heavenly Dove.

Drum
Writing Desk
A message bearing Dove.
The Heavenly Father's peaceful Dove.
April 11th 1847
A Pillar
A Tree from Father James.

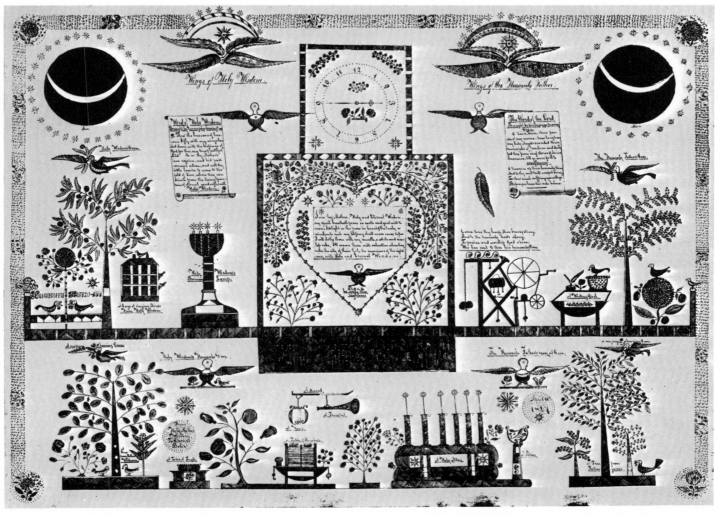

Fig. 11. *From Holy Mother Wisdom to Daniel Boler.* New Lebanon, 1847. White paper; size: height, 17″; width, 20″. (Courtesy of The Western Reserve Historical Society.)

known order, beautiful and complex, appearing to have "an existence in nature"; and "symbolic drawings, flowery, architectural, geometric or resembling oriental arabesques."

Now, more than a hundred years after the first Shaker inspirational drawings were made, it is impossible to reconstruct the actual circumstances of their production. Evidence is strong, however, that, like the songs, dances, and other gifts, they are expressions of deeply moving experiences, mysterious in many ways yet fully explainable in terms of Shaker culture. They are certainly neither automatic nor spiritistic. The spirit drawings to which Wilkinson alludes, as well as those striking but obviously pathological scribblings found in the literature of paranoia-religiosa, are rude and often morbid and are unaccompanied by the finely inscribed explanatory texts which in the Shaker designs reveal a deliberate artistry. Furthermore, the subject matter of Shaker religious art is expressed in conventional forms and patterns, which clearly distinguished them from the cryptic and loosely executed drawings accepted as automatic. The vision of the instrument was not immediately committed to paper. A past experience was reviewed and re-created with an attention to form and to the spatial requirements of the design indicative of careful forethought; the compass, ruled lines, and preliminary sketches were often employed. The fact that many inspirational drawings were done by persons who had not themselves been subject to "the vision beautiful"—a situation similar to that in the collaboration on words and music in the composition of Shaker spiritual songs and in the recording of the instruments' messages by scribes—also precludes the possibility of an automatic origin. If supernatural agencies were at work, some of the drawings would undoubtedly have been done by the brethren, who shared the gifts of instrumentship with the sisterhood, but apparently all were the work of female Believers. It is also unlikely that the inspirational drawings were ends in themselves made under automatic control, since they were often intended as presents to other persons. Though they were usually unsigned, they customarily bore the names of the persons to whom they were lovingly dedicated. Even the assertion that certain designs and emblems were dictated by a spirit or executed by a spirit's moving the hand of the writer (Plate VII) implies consciousness; the process is just another example of the practice of externalizing inner inspiration.

The respect with which certain known authors and artists were held in the community provides additional proof that the drawings were not an expres-

sion of the abnormal. In certain instances the instruments were encouraged in their work by release from part of the daily routine. Thus Paulina Bates, the author of *The Divine Book of Holy Wisdom,* was "furnished a room in the most still and retired part of the dwelling house, for her accommodation, to resort to, whenever she was summoned by the trumpet of the holy Angel, to receive the word of God." Polly Reed was one of the most talented women in the Church family at New Lebanon. The colored maps executed by this eldress and school teacher reveal the same facility with pen and brush as her more imaginative drawings. A related instance concerns Mary Hazard, who went to New Lebanon from a distinguished Rhode Island family. A uniform delicacy and artistry mark Mary's chirography, both on the religious songs copied, and the musical scores "pricked," for others and on the cards of love and other messages which she herself had received by inspiration. Another example is the exceptional work of Sister Hannah Cohoon of the Hancock, Massachusetts, society. She was both a visionist and an artist, and she signed her name in full to her work (Plates VI, VII, X). In these three instances, and probably in others, a latent talent or interest was awakened and not miraculously created or pathologically conditioned. The work has an artistic unity, even though the artists—like the Fraktur painters of the Pennsylvania Germans and the nuns who embellished the sacred books at Ephrata—were untrained in any method or school.

To credit the drawings, paintings, songs, and messages to supernatural intervention is to misinterpret the powerful currents of faith and emotion fed by the reservoirs of Shaker culture. Although these manifestations are the work of individuals, they reflect the workings of a communal, or folk, mentality deeply tinted with mysticism. The Shakers believed in the soul's eternal progression, a continuity unbroken by death. Ann Lee taught that the soul was truly resurrected only when it died to sin, when "the natural, carnal plane of existence" was abandoned for the regenerate life. The lower nature must be crucified. Only by the cultivation of the inner life could the pure spirit of Christ unfold in the individual. Mother Ann's doctrine, unquestioned as that of one acknowledged as the reappeared Christ, involved the tireless seeking for union with the divine: the goal, a millennial society which would be the earthly counterpart of the perfect heavenly church.

Life and death assumed new meaning to those absorbed in this ideal. Of chief concern, in connection with this study, was the establishment of a direct and

natural spiritual relationship between living Shakers and persons in the next world who had advanced nearer to perfection and a complete resurrection. It is also important to note that, in separating from an uninspired, material-minded world and in rejecting as imperfect both human institutions and human guidance, the Believers placed their trust in the divine will as revealed by the prophetess Ann and inspired instruments in the society.

A commonwealth of the spirit can be conceived of only in mystic terms, and it is the mystic aspects of Shaker thought that clarify the various phenomena of the period. In a religion which held that the divine was present in human life, that the departed associated with the living, that heaven was a state of the soul, and that the living therefore already participated in a celestial life, it was not strange that the instruments should have couched their revelations in literal and personal terms and should have represented the heavenly saints as actually singing songs, uttering injunctions, and distributing gifts. These seers had been chosen or self-chosen for their sensitivity to spiritual influences, as instruments finely tuned to prophecy and the interpretation of Shaker ideals, as vessels to hold God's word. There is no doubt that the afflatus beginning in 1837 was real, that it was powerful and contagious; and that in those members of the order most deeply inspired it was the inner voice that spoke, the inner vision that encompassed ideal scenes.

It is not surprising, therefore, that these scenes represent transcendental values. Romantic or secular matter as such had no place in a movement opposed to worldliness. Portraiture extolled individuality; the heads in Plate IX are alike, symbolic of the equality and union of all members of the millennial church. Even objects from the world of nature were valued less for their intrinsic loveliness than for the greater abstract beauty for which they served as emblems. According to the visionists, the aspirations of the period could best be expressed in signs or figures.

In these emblems, however, as in the messages and songs, one catches more than a glimpse of human desire. Although the Shakers were opposed to instrumental music, there are elaborate musical instruments in the drawings, just as there are references in vision and song to golden harps, bright shining trumpets, and the "holy instrument of God" with its "fifteen connecting instruments." Intolerant of jewelry, they nevertheless received with delight such emblems as chains of pure gold, diamonds, pearls, amethysts, sapphires, and golden finger rings. The plain Shaker houses have no relationship to the mansion of Holy

Mother Wisdom (Plate XII). Although the Shakers were used to the simplest food, they relished the sweet-scented manna and the exotic fruits on the tree of life. Although they were accustomed to wooden utensils and unadorned stoneware, they found satisfaction in silver cups and golden bowls, both in the drawings and in their sacraments. They humbly labored without material reward, but they welcomed spiritual gifts of mantles, crowns, wreaths, silver sacks of comfort, and golden chariots to take them to their eternal home.

In an account of the spiritual robes presented to the Believers on the eve of their march up to the holy mountain in Hancock (1842), the longing for beauty, bright color, and luxurious raiment finds apt expression. Shaker apparel was extremely plain, but for this occasion each of the brethren received "beautiful fine Trowsers . . . silk gloves."

Although these presents were "heavenly," they were none the less real for the Shakers and perhaps compensated for what was denied them in their daily lives. An almost sensuous satisfaction must have accompanied the receiving of the aforementioned adornments. The doctrine of self-denial imposed a repressive discipline on the Believer. Communication with the world and intercourse with the opposite sex were taboo. Ornament was forbidden. But in the songs and in the rituals, in the colorful gifts and messages from Mother Ann and other departed spirits, and in the pictures brightly representing the heavenly sphere, Ann's followers found a promise of celestial bliss, a childlike pleasure in, and a temporary release from, the restrictions of an ascetic routine.

Bright with the promise of glorious rewards and the consciousness of union with the divine, the gospel of Ann Lee filled the hearts of the Believers. Like that of the devotees of other spiritualistic sects, their joy overflowed, often incoherently and extravagantly, in song and dance. It found its own ways of expression in the Biblical-like messages and finally in imaginative graphic forms. Just as the idealism of the Shaker's faith gave distinction to lives that otherwise might have been insignificant, so an intensified consciousness of God in the period of this study guided into unique channels those qualities of purity, humility, innocence, and love fostered by a belief in the resurrection life. The inspirational drawings in particular record brilliantly an earnest experiment in re-creating in nineteenth-century America the aspiring life of the primitive Christian church.

In his notes on spiritual gifts for the years 1851 to 1856, Isaac Youngs observed that "there was nothing peculiar in the spiritual line occurred with us in

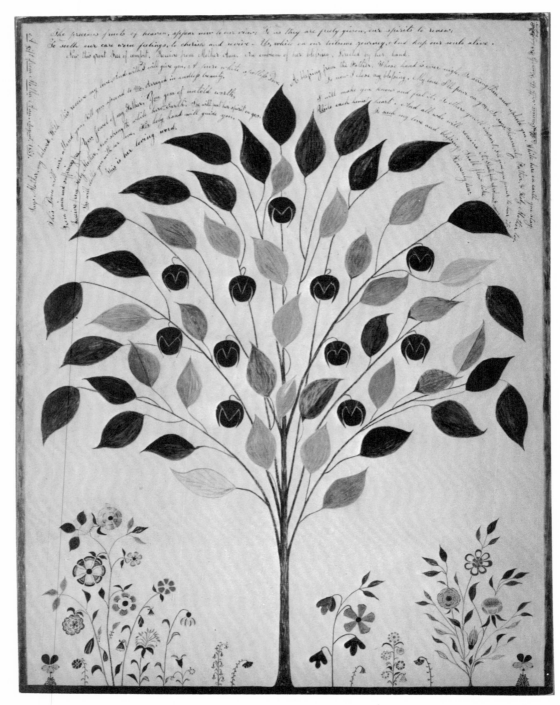

Fig. 12. *A gift from Mother Ann. Tree of comfort.* Hancock, 1859. Water color and ink; size: height, 23½″; width, 18″. (Shaker Musuem, Sabbathday Lake, Maine.)

LEFT EDGE:

A gift from Mother Ann. August, 1859.

RIGHT EDGE:

To Eldress Eunice, with the Heavenly Fr. & holy Mother's blessing.

TOP:

The precious fruits of heaven, appear now to our view; To us they are freely given, our spirits to renew;

To sooth our care worn feelings, to cherish and revive-Us, while on our toilsome journey, And keep our souls alive.

Now this great Tree of Comfort, Receive from Mother Ann, An emblem of her blessing, Directed by her hand.

LEFT:

Above branches:

Says Mother, my beloved, With this receive my love, And with it I will give you, A pure white spotless Dove.

This Dove will sure attend you, Till you ascend to Me, Arrayed in endless beauty,

From pain and sufferings free. You Jewel of my Father, You gem of untold worth,

Receive from Holy Mother, New strength while here on Earth. She will put her spirit on you.

She will clothe you with her love, Her holy hand will guide you, This is her loving word.

RIGHT:

Above branches:

A blessing from the Father, Whose hand is ever nigh, To strengthen and uphold you, While here on earth you stay.

So now I close my blessing, My love I'll pour on you, So says the heavenly Father, & Holy Mother too.

I will make you know and feel it, To others you'll impart, I'll give you power to bear it.

Unto each honest heart. And all who will receive it, Shall feel refreshment new.

To such my love and blessing, Shall flow like Heavenly dew.

the course of these six years. Inspiration and notices from the spirits have been comparatively rare." It is a measure of the secrecy involved that this annalist, who knew in 1843 of the "many drawings, signs and figures of objects in the spirit world," should have called such notices rare in the very period when they were most common. Most of the larger designs in color were produced in the period 1851–57, with at least five such documents recorded in 1854.

The explanation would seem to lie in the fact that the sisters who produced the major drawings were the ones most sensitive to the manifestations of the preceding years, and that, as the excitement abated, they could view more objectively and depict more comprehensively the gifts which had been received in the order. No doubt these "sensitives" still had visions themselves, though their revelations were probably more often committed to paper than given out in meeting. In thus recording their gifts, they were engaged in a completing work — a summation in graphic form of the spiritual experience of the whole Shaker community.

By the time of the Civil War gifts and revelations had virtually ceased, even among those who had been most deeply inspired. After the war elements of worldliness increasingly vitiated what was formerly a pure and primitive culture. The temper of the time was changing and was no longer so charged with spiritual meaning as formerly. Membership in the sect began to decline, and an independent mode of life and thought began to pass away. Soon it was too late to revive a spirit which had had only a brief opportunity to exhibit its chaste essence in rhythms and in lineal patterns and color.

The extant drawings may be divided into five distinct classes: (1) the sacred sheets of 1842–44, (2) the beginning of articulate symbolism, (3) the leaf and heart rewards, (4) the floral and arboreal (tree of life) drawings, and (5) major drawings, containing varied symbols. The sacred sheets of 1842–44 are composed of cryptic pen-and-ink characters arranged in various geometric patterns. Following closely on these documents with their veiled symbolism are pages covered with articulate writings, each message enclosed in the outline of a heart, triangle, square, circle, or other geometric figure. Small pictures, such as of a house, tree, or grove, are introduced for the first time but are definitely subordinate to the text. The use of colored inks is another sign of progression. Confined with two or three exceptions to the years 1843–44, the cutout leaf and heart rewards mark another developmental stage: the heart and the leaf have

achieved their full symbolic significance, and characteristic emblems, such as angels, crowns, swords, and doves, first appear as decorations amplifying the text. The major inspirationals date from 1845 and fall into two groups. In one are depicted floral and arboreal designs and emblems, variously interpreted and done in color. The tree of life is a favorite device. In the last group the symbolism is more elaborate and abstract. Floral motifs persist but do not dominate a carefully planned pattern rich with allegorical meaning. Some of the finest drawings, like those in the preceding class, are glorified by color; others are done with pen, and blue and/or red inks are applied with delicate precision.

1. The sacred sheets (Figs. 1, 2)

In these documents, transitional between the purely written and the largely pictorial, the producers attempt to give pictorial form to their psychic experiences. Messages committed to writing during the previous two years or so are now expressed in graphic form. Figs. 1 and 2, selected from a group of similar manifestations, were drawn, or written, at New Lebanon in 1844 after a vision or the reception of a message from Holy Mother Wisdom, transmitted by her "Holy Angel of many signs." Sun, moon, and stars are represented in Fig. 1, as well as four formalized trees, or bushes. The other diagrams may depict jars or plots of flowers and shrubs with connecting paths. Fig. 2 likewise may have been designed as a chart of a formal garden and anticipates the later floral drawings. Just as these figures may have stood for a beautiful and orderly paradise, so another chart represents the heavenly kingdom with its twelve gates and its abodes for the righteous.[7] (See Rev. 21:10–13.) Related to the sacred sheets are a number of documents filled with mystic writing and characters, apparently intended to express messages received in unknown tongues. Although undated, these manuscripts doubtless belong to the same period. In only one example, that depicting a lamb (symbol of humility) and a watch (symbol of mortality), does pictorialism play a part.

2. The beginning of articulate symbolism (Fig. 3)

Intelligible messages from different individuals in the spirit world are here arranged in geometric compartments and inscribed with various inks. Sun,

[7] "The Shakers: Their Arts & Crafts," *Philadelphia Museum Bulletin*, Spring, 1962, p. 95.

City of Peace Monday July, 3rd 1854. I received a draft of a beautiful Tree pencil'd on a large sheet of white paper bearing ripe fruit. I saw it plainly; it looked very singular and curious to me. I have since learned that this tree grows in the Spirit Land. Afterwards the spirit shew'd me plainly the branches, leaves and fruit, painted or drawn upon paper. The leaves were check'd or cross'd and the same colors you see here. I entreated Mother Ann to tell me the name of this tree: which she did Oct. 1st 4th hour P.M. by moving the hand of a medium to write twice over Your Tree is the Tree of Life. Seen and painted by, Hannah Cohoon.*

*The inscription "Aged 66" appears in a corner of the reverse side of the sheet.

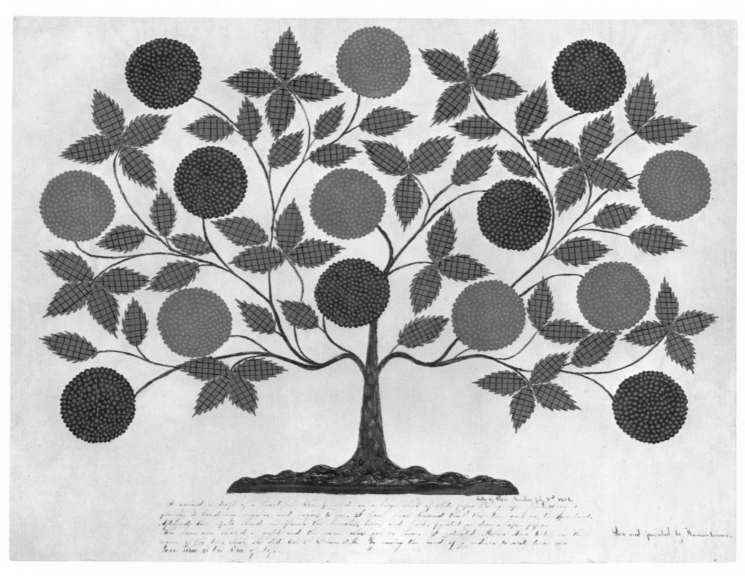

Plate VII. *The Tree of Life.* Hancock, 1854. Ink and water color; size: height, 18⅛″; width, 23⁵⁄₁₆″. (Shaker Community, Inc.)

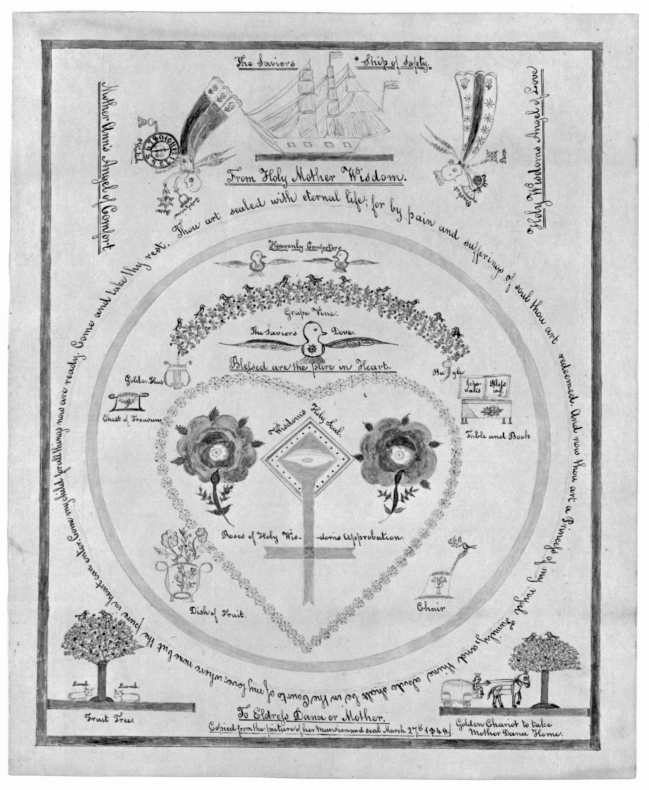

Plate VIII. *From Holy Mother Wisdom. To Eldress Dana or Mother.* Hancock, 1848. Ink and water color; size: height, 9²⁵/₃₂″; width, 7²³/₃₂″. (Shaker Community, Inc.)

Top, left to right:

Mother Ann's Angel of Comfort.
Watch
Rose
Cup of wine
The Saviors Ship of Safety.
From Holy Mother Wisdom.
Basket
Ball of love
Box
Holy Wisdoms Angel of Love

Center: *Around circle:*

Thou art sealed with eternal life; for by pain and sufferings of soul thou art redeemed. And now thou art a Princess of my royal Family, and thine abode shalt be in the Courts of my love; where none but the pure in heart can enter. Come my child for all things now are ready. Come and take thy rest.

Within circle, top to bottom:
Heavenly Comforters
Grape Vine.
The Saviors Dove.
Blessed are the pure in Heart.
Golden Harp
Bugle
Jehovah's Blessing.
Chest of Treasures
Table and Book
Wisdom's Holy Seal.
Roses of Holy Wisdoms Approbation.
Dish of Fruit.
Chair

Bottom, left to right:

Lamb. Lamb.
Fruit Tree.
To Eldress Dana or Mother.
Copied from the picture of her Mansion and seal March 27th 1848.
Golden Chariot to take Mother Dana Home.

moon, and stars again appear, this time in color. Included also in one figure are a staff of love and a diamond of love (colored yellow), as well as actual miniatures depicting "Mother's pleasant grove," a basket of flowers, and a primitive landscape of house, trees, and sky. A long narrow space devoted to a message from Garret K. Lawrence is called a piece of embroidery, a term that indicates a desire to present the communication in attractive graphic form. In another example the messages are written within the eight segments of a wheel, "the everturning and bright Golden Wheel of Eternal power and Truth."

3. The leaf and heart rewards (Figs. 4, 5, 6)

The leaf rewards, or gifts, possibly owed their origin to the manuscript songbooks, which were also presented by one sister or brother to another as tokens of affection and esteem.[8] In a collection of songs begun by Mary Hazard of New Lebanon in 1839,[9] two successive pages contain a message of love from Mother Lucy to Sister Molly B, written on a simply delineated leaf, a "golden leaf . . . from the Tree of songs" bordered by a song and the early literal notes of Shaker hymnology (Fig. 4). The date on this gift is November 28, 1839. Not until 1843, however, did the leaf tokens assume the characteristic form of green paper cutouts.

The earliest example—"A holy leaf from eternal wisdom, to Eldress S. Betsy Darrow" (New Lebanon)—is dated June 8, 1843, the gift itself having been received on May 21. The pale-green token resembles the leaf of an elm. The leaf rewards of 1844 are smaller (about 6½ inches long including the stem) and are usually bright green on one side and a paler hue on the other. The simply decorated borders are not serrated, as the border of the 1843 example is. These tokens are seldom if ever embellished with symbols; the pattern itself, representative of the tree of life, sometimes seems to fulfill the intent of the designer, and other pictorial decorations are few. The leaf motif is often repeated in the more ambitious floral and arboreal drawings.

Square and rectangular sheets of white, pale pink, or rose paper, called cards of love, also exchanged in 1842 and 1843, bear inscriptions similar to those on the leaves and the hearts. Small round tokens called seals, cut from wine-

[8]For example: "A Collection of Songs, or, Sacred Anthems. Mostly given by Inspiration. Written for Betsey Bates (By Eldress Polly R. Reed) Beginning November 29th 1840."

[9]MS, Andrews Coll.

colored papers and sometimes having feathered edges, were inscribed at a slightly later period (1845–47). Similar tokens cut from tinted paper in the form of a fan or a mirror date from 1847.

Individual heart rewards were common among the Believers in 1844. Painstakingly though anonymously inscribed on both sides, these little pink, yellow, or white tokens (the valentines of the Shaker world) bear gentle messages of encouragement and praise to a named recipient. Here the gift is ornamented with emblems: simple diagrams of harps, crowns, roses, doves, candles, and swords, usually placed at the end of the text. The borders are also decorated. A common motif in religious allegory, the heart is also encountered in the Pennsylvania German Fraktur paintings,[10] as well as in the religious "notices" of the True Inspiration Congregations of New York and Iowa, and it, like the leaf, is later employed either as a central or as an accessory device in the elaborated drawings.

4. Floral and arboreal (tree of life) drawings (Figs. 7, 8; Plates I, II, III, IV, V, VI, VII)

Although the sacred sheets, leaf and heart rewards, and related pictorial efforts of the period forecast the essential character of the large detailed inspirational drawings, a radical advance in conception and technique is represented by the later drawings. Greater intricacy in design, increased scope of imagery, and an unrestricted but controlled use of color all appear abruptly. Yet in these more important drawings, inspiration at last provides pictorial values worthy of the deep currents of feeling which swept the communities of Shakers during this remarkable chapter in their history.

It was natural that the authors of the designs should attempt to portray the glory of heaven and the spiritual life in terms of natural beauty. The mystic communion of the Believers with God involved a sensitive kinship with nature. Their villages were situated in the unspoiled countryside, environed with woods, hills, and fields. One of the chief industries of the society was the collection or cultivation and the preparation of medicinal flowers and herbs. Although plants were sought solely for utilitarian purposes, and although gardens,

[10] It is interesting to note that the arts of Fraktur practiced by the Pennsylvania Germans included gifts "on loose leaflets," also known as rewards of merit (See Henry C. Mercer, *The survival of the mediaeval art of illuminative writing among Pennsylvania Germans*, Philadelphia, 1898).

Holy Mother Wisdom's Wings.

In book:

Words of Holy Mother Wisdom. I will, saith Wisdom, show unto my people many hidden mysteries which have been kept from the great and wise ones of the earth, and will, in my own time, reveal them unto babes and sucklings, Yea to those who follow the meek and low spirit of Christ the Savior; these I will crown with my love, & bless them with my blessing.

Holy Wisdom's loud sounding trumpet of freedom

Come tune your harps, ye valiant souls
And praise your God above;
For he hath sent his blessed Son,
To crown you with his love.

Holy Mother's cage of message bearing dove.

O my Father, give me the spirit of a D-o-v-e & the lowly title of a Lamb. Clothe me with a garment of charity for my enemies, who daily deny thee, O my God.

On scroll:

The Savior's Prayer.

O my heavenly Father, give me strength, give me power, & lead my spirit on to thy mansion of peace. Bless them that curse me, and seek to destroy crucify and nail me to the cross. In thy mercy O my God forsake not my desciples. for my Father hath called me, & I must go. O send thy bright Angels to protect, to strengthen & direct them, while passing thro this flood of sorrow.

A bread plant.

Watch and pray, for ye know not the hour of my coming.

In heart:

Voice of Wisdom.

I'll guard my Anointed, my chosen on earth,

And guard them with pleasure to my mansion of rest
Where peace like a river so gently doth flow,
And heavenly flowers so sweetly doth grow.
O come my beloved come rest on my love,
And feed on my lillies in mansions above
Where Angels most holy their praises do sound
To those who are faithful & with life are crown'd.
Peace, peace saith God.

A spear.

This is the crown of plaited thorns,
Which on my head was placed.
To show the cruel hearted band
That round my cross did stand.

This is the sword that pierced my side,
And blood did flow therefrom.
Then to my God I lowly cried
Thy will not mine be done.

Emblem of meekness

The Heavenly Father's Wings.

On scroll:

I will saith the Lord comfort Zion, I will [. . .] her waste places, I will make the wilderness a garden of my love. Joy & thanksgiving & the voice of praise shall be heard thereon. Lift up your eyes to the heavens, and look upon the earth beneath, for the heavens shall vanish away, and the earth was old like a garment, but my word shall never fade. I am the Lord of Hosts, who divideth the sea, whose waves roareth. The Lord of Hosts is my name, therefore, all ye people fear & reverence my holy word, for I am the All seeing eye that never sleepeth.

The Heavenly Father's lamp of eternal brightness.

The Heavenly Father's tree, bearing balls of tribulation.

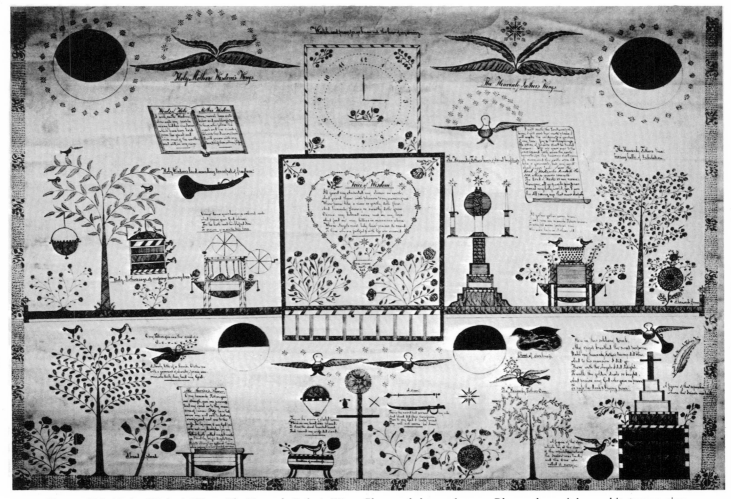

Fig. 13. *Holy Mother Wisdom's Wings. The Heavenly Father's Wings.* Place and date unknown. Blue and rose ink on white paper; size: height, 19½"; width, 27". (Courtesy of The Western Reserve Historical Society.)

Beneath scroll:

I'll gather gather every hour,
A ball from my heavenly Father's bower.
To comfort every faithful soul
Who ever keeps in Mothers fold.

A heavenly flower
Cloud of darkness

More in this solitary tomb,
My spirit breathed the sweet perfume,
Until my heavenly Father's trump did blow,
And to his mansion I did go.

There with the Angels I did delight,
To walk the golden streets so bright,
And praise my God who gave me power,
To pass the dark & trying hour.

A quill from the Heavenly Father's Wing
The Heavenly Father's Dove.
A figure of the sepuchre where the Savior
was laid.
A figure of the stone which lay at the door
of the sepulchre where the Savior was laid,
and the Dove who rolled it away.

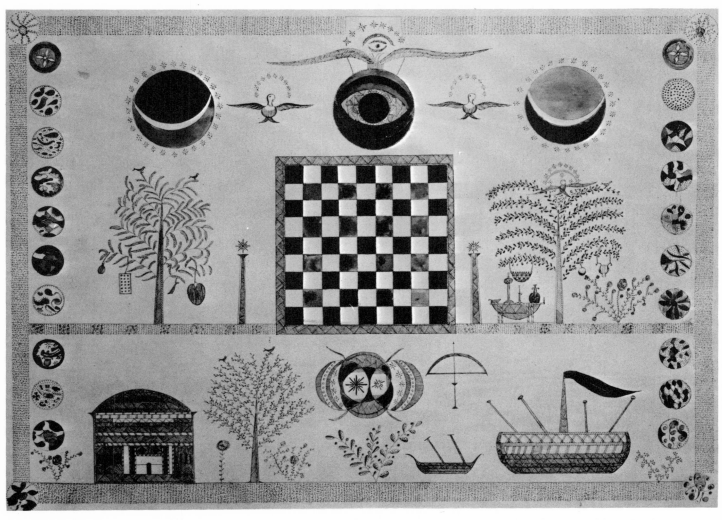

Fig. 14. Symbolic design. New Lebanon (?), date unknown. Pen and blue ink; red and blue wash; size: height, 15″; width, 20¾″. (Philadelphia Museum of Art; photograph, A. J. Wyatt, staff photographer.)

meadows, orchards, and woodland were viewed primarily as a means of sustaining the Church, an appreciation of color, fragrance, and form was at least latent. Sanctions accompanying the spiritual upheaval released desires as a liberalized doctrine might have done, and the Believers turned to the beauty surrounding them for the fittest expression of a perfect immortal world.

The floral and arboreal emblems in the drawings reveal a love of nature. Such emblems as the tree of life, the burning tree, and the cedars of Lebanon were traditionally endowed with appropriate significance. The tree of life became a favorite subject, assuming many forms and meanings. This and related decorative motifs may have been suggested by materials familiar to the Shakers before they joined the society: appliqué and embroidered quilts and bedcovers, patchwork and hooked rugs, cross-stitched samplers, chintzes, wallpapers, embroidered pictures, needlepoint, designs on china, stencils, and printed textiles. However, the trees, leaves, bowers, and flowers of the drawings have a certain archaic character, supporting the view that they were imaginative concepts, probably based on Biblical sources, such as Genesis, Esdras, and the Book of Revelations. The Believers had little contact with Indian folklore and none with Eastern art or the literature of pagan mythology. On the other hand, they were versed in the stories and allegories of the Old and the New Testament. Their religion was based on primitive Christianity, and reading was confined almost exclusively to the Bible, concordances, and dictionaries and to books and pamphlets on Shaker doctrine.

Such absorption in scriptural literature is reflected in the diction of much of the inspirational writing, the verses and legends in the drawings, and the use of emblems (chiefly in group V drawings) deriving from the Bible, such as the well of Samaria, the ark, "The cup from which the Saviour drank at the well," Abram's altar, the Red Sea, "Sarah of old," Jeptha, the woman of Samaria, and shewbread. The wine press and the vineyard, angels and doves, and trumpets and harps are favorite subjects, as is the fountain, used by the ancient Hebrews as a symbol of life-giving power and celestial happiness. The sickle, the bow and arrow, ornamental lamps and candlesticks, seals, golden chariots, the pillar of light, the cross, the all-seeing eye, the bread plant, the fig and the weeping willow, and the Cedar of Paradise may all be traced to the same source.[11]

[11] Some Biblical emblems in Shaker inspirational designs are found in such nineteenth-century Masonic frescoes as those painted on the walls of Hall's Tavern in Cheshire, Mass.: Noah's ark, the all-seeing eye, the sun, circles, a candlestick, open books, a bugle or trumpet, crowns, feathers, and a "royal arch" decorated in part in the design of a checkerboard or mosaic pavement.

One of the earliest references to the tree of life occurs in *Millennial Praises* (1813), where that title is given to Hymn XXVI. This book was published and constantly used by the Hancock society, and it is possible that here was the source of a motif common to the drawings done at the City of Peace:

On Zion's hill is clearly seen
By souls who do not live unclean,
The tree of life, forever green,
Of God the Father's planting:
Establish'd by the Lord's command,
This tree will there forever stand,
Diffusing blessings through the land,
Of Christ the Savior's granting.

Its roots are deep, and firm and strong,
Its branches beautiful and long,
With verdant leaves, forever young,
A spacious field it covers:
The hungry soul that's destitute,
Beneath its shadow may recruit;
For it abounds with heavenly fruit,
Much fairer than all others.

This hymn, of unknown origin, was probably sung even earlier, and in other Shaker villages. A manuscript hymnal prepared in 1808 by David Slosson, the first tailor at New Lebanon, contains another version of the song. The first verse reads:

On Zions hill, plain to be seen,
By Souls who do not, live unclean,
The Tree of Life, all pure and clean
Of God the Fathers planting:
On Zions hill, it firm doth stand,
And well Establish'd, by Gods hand,
Not like the house, upon the sand,
But firm by heavens Granting.

The theme was revived in "Beautiful Tree" written (probably at New Lebanon) in 1822:

How glorious is that shining tree
That Father James in vision saw [Plate I],
Much brighter than the sun can be
Are those who keep Jehovah's law
Those who obey the heavenly call
Like blooming trees that never fade
Whose leaves will heal the nations all
That put their trust beneath their shade.

The symbolic treatment of nature, prefacing the use of plant forms in graphic designs, is again illustrated by a song of 1830, "The Union Plant":

> We love the precious union plant,
> We love to see it growing,
> It is the life of every saint,
> We feel its virtues glowing.
> This plant is found in vallies low,
> Increased by cultivation
> And it will flourish there and grow,
> And fill the new creation.
>
> Now to its branches we'll resort
> And fruits most luscious gather,
> 'Tis here we find divine support
> On which we live forever.

Also, in "Healing Balm,"

> The tree of peace unfolds its leaves,
> And spreads its branches wide,
> Beneath the holy shade it gives,
> The gentle lambs abide.

The song "Pure Crystal Streams are Flowing," written at Hancock in 1842, employs the figure again:

> Pure crystal streams are flowing
> Come and welcome all that will,
> Drink and live forever.
> The tree of life on either side
> Which bear twelve kinds of fruit
> And every month does yield it
> Its leaves will heal the nations.

Allusions in the inspirational messages indicate that the tree of life, as well as the fruit-bearing trees and the "beautiful and pleasant smelling flowers," represented the unspoiled loveliness of a Garden of Eden. Other references in the records of 1842 concerning the holy mounts indicate that they were chosen not

BORDER:

Starting with figure of hand, lower left:

I am the Lord of Hosts the Almighty Creator of Heaven and Earth. The beginning and the End. I come to call sinners to repentance to strengthen the weak, and comfort the strong. Therefore hear ye my word, O ye people, and fear and reverence my holy work, saith the Lord.

TOP:

Wings of the Heavenly Father.
The Wings of Holy Wisdom.

In open book:

The Book spoken of in Revelations sealed with Seven Seals. Which the Mighty Angel brought and commanded John the Revelator to Eat.

Under circle at left of clock dial:
The Heavenly Father's Word.

Above circle at right of clock dial:
Holy Wisdoms Roll of Eternal brightness, sealed with an Eternal Seal.

On scroll carried on dove's wing:

O my holy heavenly Father
In thy mercy condescend,
To protect my chosen people,
Be their Father & their friend.
Do extend thy loving kindness
Do thy holy power distill
That in hours of tribulation
They may do thy holy Will.

CENTER, LEFT TO RIGHT:

A Centaury Flower.
A Cage of spiritual singing birds.
A Heavenly Fruit Tree.
A basket of heavenly fruit.

In heart:

O daughter of Zion lift up thine eyes and behold all these things I have caused to be placed before thee. As I live, saith the Lord, my faithful servants shall surely be clothed with the ornaments of Heaven, and be crowned with life-everlasting. They shall not hunger nor thirst, for he that Hath mercy on them, shall lead them on to fountains everlasting, saith Wisdom.
A spiritual Lamp.
An Instrument of Heavenly Music.

BOTTOM, LEFT TO RIGHT:

The Prophet Daniel's Prayer, when in the Lion's Den.
Bread Plant.
A Rose Bush.
A Weeping Willow.
A figure of the Prison where Mother Ann was confined after she came to America, and the holy Angel in the form of a Dove, that guarded her.*

In seals:
From Holy Mother Wisdom to Hannah Ann Treadway. April 27th 1845.

**The reference here is to Mother Ann's imprisonment at Albany and Poughkeepsie in 1780. Ann, William Lee, and James Whittaker were arrested on the charge of being British emissaries but were later released by Governor DeWitt Clinton of New York.*

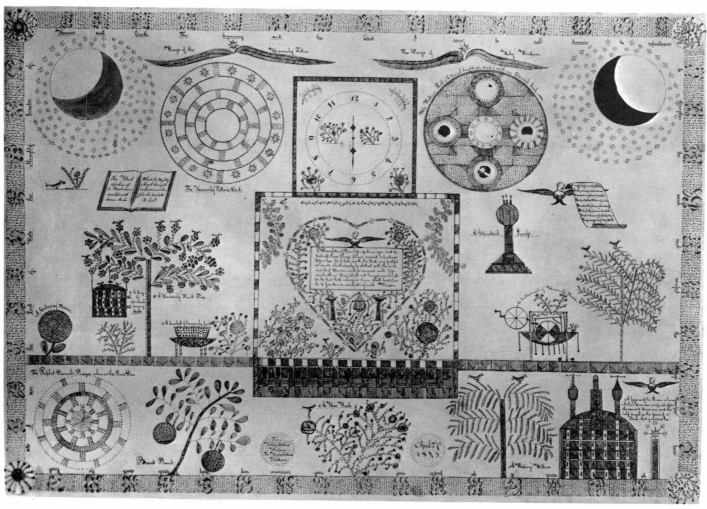

Fig. 15. Symbolic design. *From Holy Mother Wisdom to Hannah Ann Treadway.* New Lebanon, 1848. Pen and blue ink; red and blue wash; size: height, 15″; width, 20½″. (Philadelphia Museum of Art; photograph, A. J. Wyatt, staff photographer.)

TOP, LEFT AND RIGHT:

As a specimen of what the treasures of Heaven are, you may now receive some little tokens of love, love & blessing from all your Heavenly Parents.

LEFT, TOP TO BOTTOM:

Patience & Meekness have won to your Crown many bright S-t-a-r-s.

On crown:
From Fr Joseph

Within vine:
Plumb Cake.
Eldress Ruth.
A Grape vine from E. Rufus.
Rose of Jerusalem from Eldress Ruth.

CENTER, TOP TO BOTTOM:

Around circle:
Good Father William now doth say, Receive ye this on my birthday. April 8th 1854.

In heart:
Wisdom waves her golden banner and bids her little one draw near; Shout aloud & sing Hosannah, for truly you have nought to fear.
Holy Wisdom.
A Fountain of Love.

On scroll held by dove:
Come O come unto me my little one saith Wisdom & you shall partake of every kind of fruit in my heavenly vinyard.
From Elder Ebenezer
A Rivulet of holy Waters from Mother Ann.

While larger fish the small consume
Your virtues like fair roses bloom.

St. John.

RIGHT, TOP TO BOTTOM:

A sprig from the Tree of Virtue from King Solomon.
A Strawberry-Vine from Mother Lucy.
A Box of Jewels from Mother Lucy.
A Branch from the Tree of Peace & a Heavenly Dove from Father James.

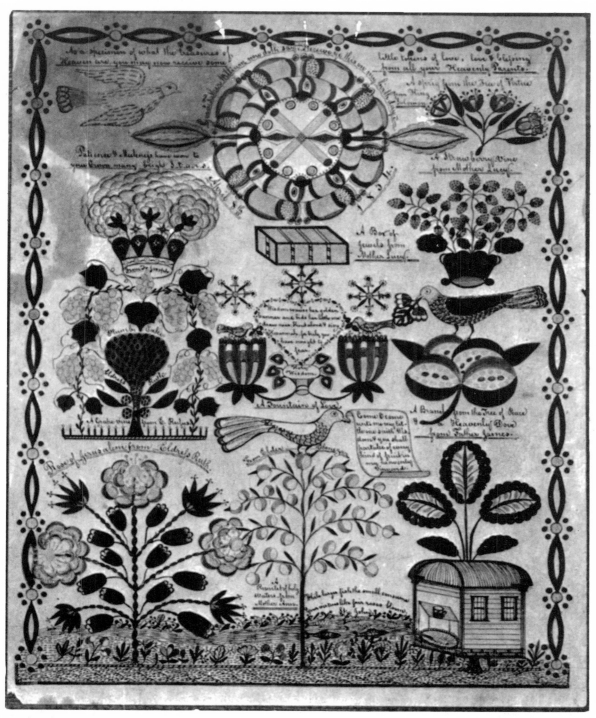

Fig. 16. *Little tokens of love, love & blessing.* New Lebanon, 1854. Water color on pale-blue paper; size: height, 10″; width, 8″; stained in upper corner. (Location unknown.)

only for their elevation but also for their freedom from all trace of human presence and "never drenched in blood." A mount was a consecrated place watched over by holy angels and "for a long time sacred to the most high God." Growing there was the tree of life, beneath the shade of which "the children of Mother Ann will find the blessing of heaven." For sustenance there was "a beautiful orchid of fruit bearing trees of many kinds, such as apples, pears, apricots, pomegranates, peaches, cherries, and plumbs of various kinds. Also delightful and nourishing fruits are cultivated in a beautiful garden, such as grapes, pineapples, white strawberries, watermelons, musk melons and other beautiful fruits. This garden was also adorned with a great variety of beautiful and pleasant smelling flowers":[12]

> A living fountain pure and clean
> Spouts up and falls in shining spray,
> And living plants of purest green,
> Around this pleasant fount display
> Their lovely forms of heavenly mold[13]

Such a scene, half earthly, half celestial, the Shaker artists attempted to portray in color and line. Often in vision the recorders saw the heavenly counterparts of natural trees: the Celestial Cherry Tree, the Celestial Plum Tree, the Cedar of Paradise, the "English cherry tree brought from spiritual England," and trees bearing manna and strange fruits. At other times they contemplated trees of light, order, or protection.

Virtues are sometimes represented by given fruits or flowers, though the symbolism does not consistently follow such a key as this one extracted from a manuscript entitled "Presents from spiritual world," by D. A. Buckingham of the Watervliet society:

Fruits and Signification.[14]

ApplesLove

CherriesHope

GrapesStrength

FigsHeavenly Joy

[12] Hancock MS.

[13] Ibid.

[14] A similar chart in a Shirley manuscript is corroborative. It will be noted that this interpretation does not accord with the sentimental language of flowers and fruits. Traditionally, apples symbolize temptation, and figs, argument. Other examples include hope represented by the flowering almond, hawthorn, or snowdrop; union, by the whole straw; strength, by fennel or the cedar; simplicity, by the American sweetbrier; meekness, by the birch; peace, by the olive tree; comfort, by the pear tree; and so on.

Oranges	Encouragement	Pairs	Faith
Chains	Union and Strength	Peaches	Charity
Buds	Gospel Freedom and Simplicity	Plumbs	Union
		Strawberries	Union
Pearls	Meekness	Pineapple	Spiritual Sensations
Diamonds	Peace and Comfort	Roses	Love and Chastity

5. Major drawings, containing varied symbols (Figs. 9, 10, 11, 12, 13, 14, 15, 16, 17, 18; Plates VIII, IX, X, XI, XII)

The drawings in this group, produced chiefly in the New Lebanon society, are distinguished from the relatively simple tree, flower, and fruit inspirational drawings done at Hancock. At Holy Mount (New Lebanon) plant forms again appear, but in greater profusion and as parts of a large detailed pattern. The designers in the parent society turned to the Bible and other sources for a variety of other symbols, which are skillfully and harmoniously integrated. That the distinction between the work in these two societies is not always clear, however, is indicated by the unusual Hancock document "An Emblem of the Heavenly Sphere" (Plate IX) and the small record from the City of Peace (Hancock) (Plate VIII) representing angels, chariots, tables, chests of treasure, a ship of safety, and other objects selected from outside the realm of nature.

Only in exceptional instances do the message and attendant emblems emphasize evil rather than good. Then the portrayal represents the forces of temptation and darkness from which the children of Zion have been saved and with which they must contend: figures of persecution, bloodshed, pomp and pride, the darkened sun, the moon turned to blood, prisons and floods. The early persecutions endured by the Believers may have prompted such expression. They saw themselves, according to the prophetic utterances of the instruments, further persecuted, as the children of Israel had been. In the inspired messages, an angry God punishes such persecutions, just as he visited the Pharaoh and the Egyptians with the plagues. Reference is made to the flood which engulfed the world of Noah, to the angels of Revelations with their vials and sickles, and to the destruction of Babylon. Their course approved and perhaps suggested by the elders, the instruments graphically described the way of transgressors, notably those whom worldliness had lured from the Shaker Zion.

The symbolism in the New Lebanon drawings is no more consistent than it is

TOP CENTER:

An Emblem of the Heavenly Sphere.
Holy Art Thou O Lord God Almighty.
Just and Equal are thy ways. True & Right-
eous are thy judgements. Let the Earth be
moved at Thy loving Kindness. Let the
Heavens Rejoice, and All the Saints Give
Thanks. For Thine is the Kingdom & Honor,
& Glory forever. Amen.

TOP, LEFT:

Here is an emblem of the world above
Where saints in order, are combined in love;
Where thousands, and ten thousand souls as
 one,
Can join the choir and sing around the
 Throne.
Where millions, and ten thousand millions
 praise,
The Holy Two in One, through endless days.
Where all is peace, sweet love and harmony,
Through out those blissful realms tranquility.
None can disturb, nor mar the others joy,
For all have constant and most sweet employ.
Here jars nor strife no more disturb the soul
For by the Law of love, all is control'd.

TOP, RIGHT:

An emblem of the happy land above!
Where Angels join the choral song in love,
Is here portraid, that you may faintly see,
But half can not be told, nor shone, to thee.
Rejoice, go on, you'l yet obtain the sight,
An entrance in those regions of delight.
Your praise will mingle with the happy
 throng,
And to their holy circle, you'l belong.
Your voice will swell the strain of melody,
And seraphs clothed with love and purity
Will welcome you to join their band above!
Where beams eternal glory, light and love.

LEFT:

Flower of Eden	Rose of Love.
Repentance	Forgiveness.
The Celestial Plum.	Peach Tree.
Orange Tree.	Bower of Love

Apple Tree.	Treasure Table.
Writing Room	Pleasant Grove
Guardian Angel	

RIGHT:

Perfuming Lilly.	Sicamore Tree.
Protection.	Strength.
The Catery Plant*	The Celestial
	Cherry Tree.
Bower of Peace.	Lemon Tree
Abrams Altar.	Tree of Order.
A fountain of living	Pillar of light.
water	Saints rest.
	Love. Peace.
	Red Sea.

CENTER, LEFT:

Mother Ann.	Father James.
The Savior.	Saint Peter.
John.	Philip.
Matthew.	James.
Matthias.	Luke
St. Paul.	Nicodemus.
Virgin Mary.	Mary M.
Merium	Deborah.
Moses.	Aaron.
Lot.	Enoch.
Samuel.	Eli.
Elijah.	Elisha.

CENTER, RIGHT:

Father William.	Christopher Columbus.
Andrew.	James the Lesser.
Bartholomew.	Thomas.
Lebeus.†	Simon.
Mark.	Jude.
Annias.	Saphira.
Queen Esther	Judith
Sarah.	Eve.
Abraham.	Adam.
Joseph.	Isaac.
Isaiah.	Daniel.
Jeremiah.	Jonah.

*Possibly derived from the archaic word "cate,"
a delicacy.

†Lebbaeus, or Jude. Note duplicate reference
to this character.

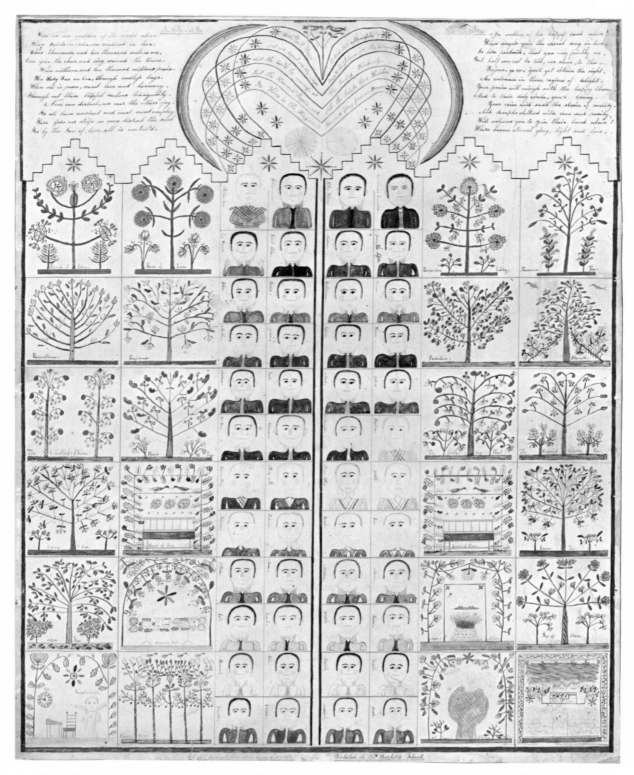

Plate IX. *An Emblem of the Heavenly Sphere.* Hancock, 1854. Ink and water color; size: height, 23¾″; width, 18⅝″.
(Shaker Community, Inc.)

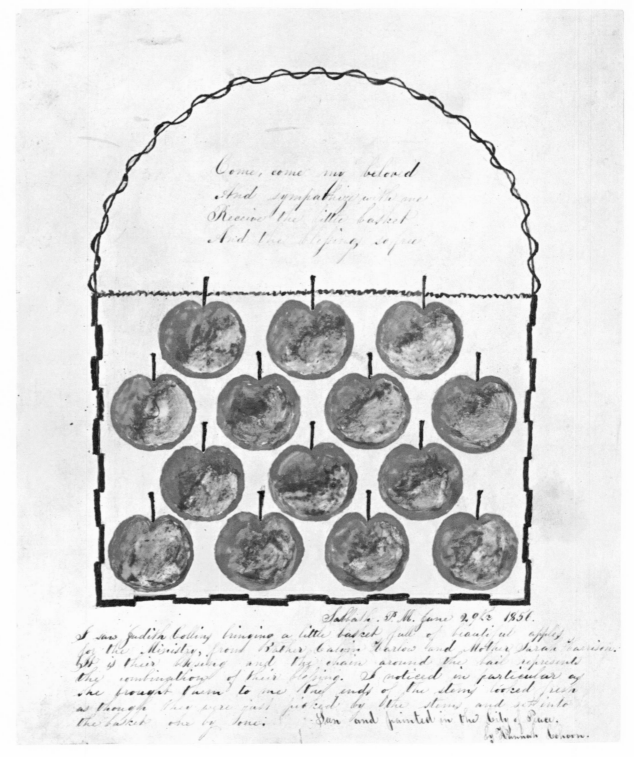

Plate X. Basket of apples. Hancock, 1856. Ink and water color; size: height, 10⅛″; width, 8³⁄₁₆″. (Shaker Community, Inc.)

Top:

Come, come my beloved
And sympathize with me
Receive the little basket
And the blessing so free

Bottom:

Sabbath. P.M. June 29th 1856. I saw Judith
Collins bringing a little basket full of beautiful
apples for the Ministry, from Brother Calvin
Harlow and Mother Sarah Harrison. It is
their blessing and the chain around the pail
represents the combination of their blessing.
I noticed in particular as she brought them
to me the ends of the stems looked fresh as
though they were just picked by the stems
and set into the basket one by one. Seen and
painted in the City of Peace. by Hannah
Cohoon.

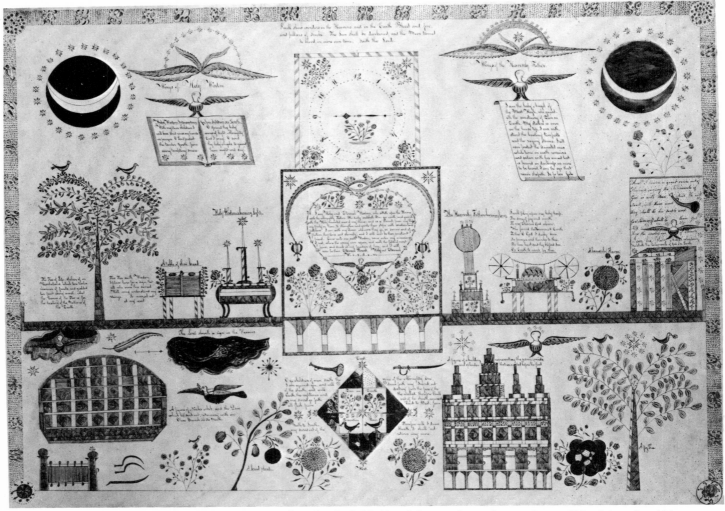

Fig. 17. *Wings of Holy Wisdom. Wings of the Heavenly Father.* Probably New Lebanon, date unknown. Pen and blue ink; red and blue wash; size: height, 19½″; width, 27¼″. (Philadelphia Museum of Art; photograph, A. J. Wyatt, staff photographer.)

TOP, CENTER:

I will show wonders in the Heavens and in the Earth. Blood and fire, and pillars of Smoke. The Sun shall be darkened, and the Moon turned to blood, in mine own time, saith the Lord.

TOP, LEFT:

Wings of Holy Wisdom.

In open book surmounted by dove:
Holy Wisdom Interceding for her children on Earth

With my dear children I will bow. And raise my hands in prayer. O Lord protect the tender Youth, from every tempting snare. O spread thy holy wings of light, Almighty God I pray. O send thy holy Angels, to guard them night and day.

TOP, RIGHT:

Wings of the Heavenly Father.

On roll surmounted by dove:
I am the holy Angel of the Most High, who guardeth the sanctuary of Zion on Earth. My

station is even on the house top. I can withstand the howling tempests and the raging storms. I will ever protect the Anointed ones while time on earth remains and satan with his armed host is bound in darkness, no more to be loosed. I am the eye that never sleepeth. Se fa len Jah.

CENTER, LEFT TO RIGHT:

The Tree of Life, spoken of in Revelations, which bore twelve manner of fruits, and yielded her fruit every month. And the leaves of the Tree is for the healing of the Nations of the Earth.

This Tree saith Wisdom, I place here for a sign, that all who view this sacred Roll, may understand my doings. So marvel not at my word.

A table of shoe bread.
Holy Wisdom's burning light.

In heart:

I am Holy and Eternal Wisdom, who sitteth upon the Throne with the Almighty Father. Who daily watcheth Zion on earth, and guardeth the Holy anointed ones of my choice; and as a Parent, pour my blessing freely on them, to strengthen and guide their steps with wisdom and patience. I am with my chosen wherever they go, in sorrow and affliction, thro' time and eternity, and I will ever be their constant friend. Come unto me, saith Wisdom, come enter my mansion of rest, where the weary can repose, and walk the fields of sweet peace, and drink at my fountain of love; and I will ever be their Eternal Parent, Holy and Eternal.
W-i-s-d-o-m.
The Heavenly Fathers burning lamp.

Over musical instrument:*

I will play upon my holy harp,
The song of joy and mirth
To my Eternal God above,
Who form'd the Heavens & Earth.
To thee O God I daily bow,

**The significance of the numbers 1 to 13 appearing in a panel of the musical instrument is not clear.*

In prayer and thanks to thee,
For thou hast sent thy blessed Son,
On Earth to work for thee.

A heavenly Flower.

Over desk:

And I heard a great voice out of Heaven saying the Tabernacle of God is with Men, And He will dwell with them and they shall be his people and God himself shall be their God thro the endless ages of Eternity I am the Holy Angel who daily Watcheth the tabernacle of God on Earth.

BOTTOM:

Over dark cloud:
The Lord showeth a sign in the Heavens

Beneath dove:
A figure of Noah's Ark and the Dove which he sent out, returning with an Olive Branch in its Mouth.
A bread plant.

Under trumpet and sword:
O ye children of men, saith the voice of the Almighty One. I am against you, and will draw forth my Sword, out of the sheath, and will destroy from the face of the Earth, the righteous and the wicked. therefore shall my sword go forth out of the sheath, against all flesh from East to West, from North to South. Therefore will I draw my sword out of the Sheath, it shall not return any more.

Around diamond:
East.
South.
West.
North.

Within diamond:
Zion on Earth.
Persecution.
Peace.
Blood Shed.
PERSECUTION [letters scattered]
A figure of a building representing the pomp, pride and splender that existed before the flood.
A fig Tree.

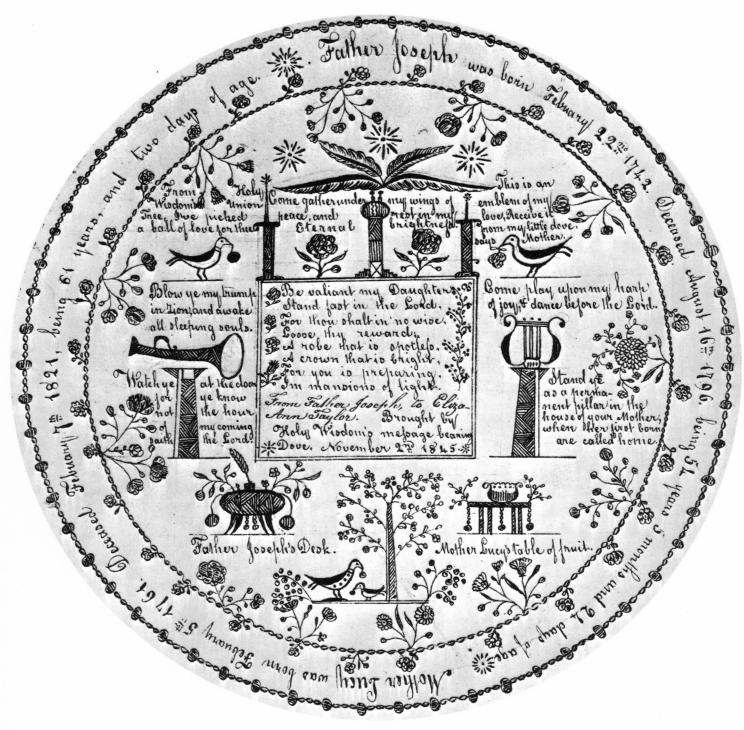

Fig. 18. *From Father Joseph, to Eliza-Ann Taylor.* New Lebanon, 1845. Blue ink on rose-colored paper; size: 6″ diameter. (Courtesy of The Western Reserve Historical Society.)

BORDER OF CIRCLE:

Father Joseph was born February 22nd 1742. Deceased August 16th 1796. being 54 years 5 months and 24 days of age. Mother Lucy was born February 5th 1761. Deceased February 7th 1821, being 61 years, and two days of age.

LEFT, TOP TO BOTTOM:

From Holy Wisdom's Union Tree I've picked a ball of love for thee.
Blow ye my trump in Zion, and awake all sleeping souls.
Watch ye at the door for ye know not the hour of my coming saith the Lord.
Father Joseph's Desk.

CENTER:

Come gather under my wings of peace, and rest in my Eternal brightness.

> Be valiant my Daughter
> Stand fast in the Lord,
> For thou shalt in no wise,
> Loose thy reward;
> A robe that is spotless,
> A crown that is bright,
> For you is preparing,
> In mansions of light.

From Father Joseph, to Eliza-Ann Taylor. Brought by Holy Wisdom's message bearing Dove. November 2nd 1845.
Father Joseph's Desk.

RIGHT, TOP TO BOTTOM:

This is an emblem of my love, Receive it from my little dove, says Mother.
Come play upon my harp of joy, & dance before the Lord.
Stand ye as a permanent pillar in the house of your Mother, when her first born are called home.
Mother Lucy's table of fruit.

in the flower and tree designs produced at Hancock; the same object may be clothed with various meanings. Thus, a tree may signify protection, strength, order, forgiveness, or repentance; a rose, patience, perseverance, chastity, faith, or charity; a ball, light or love. In an early manuscript by Miranda Barber, the key figures drawn and colored by Eldress Polly Reed ("witness and scribe") are seldom repeated in later drawings—a dove with outspread wings, the candle of the Lord, dungeons, a wreath of eternal brightness, a pillar of fire, doves of heaven bringing blessings, "the Sun clothed in Sack cloth and the Moon in Scarlet," the beasts of the fields, hail and fire and wind, showers and rivers of blood, beams and walls, rocks and mountains. Eldress Polly herself, who was responsible for many of the finest documents, apparently did not hold to her original types. The variety in nomenclature likewise suggests variety in authorship, as well as a certain creative independence in investing objects with personal ideas and feelings.

The significance of the emblems is usually apparent. As noted in the discussion of the Hancock drawings, the Believers depended on Biblical episodes for their images of celestial scenes. As in the songs and messages, objects precious and rare in a worldly sense—golden chains, jeweled crowns, diamonds, treasure chests, ornaments, exotic or supernatural flowers—could best serve to reveal the wonders of an invisible world. Clocks and watches signify mortality, the uncertainty of life, or the duty of preparedness for the Lord's coming. Angels' wings and doves with outspread wings denote protection. The eye is the all-seeing eye or the "single eye" (Matthew) that is clear-sighted. The ship of safety conveys the blessed to the crystal shore.

The drawings are rich in meaning and at the same time decoratively unique. As has been noted, it is remarkable in a culture devoted to simplicity to encounter line and color compositions displaying such versatility. It is true that certain figures in the designs, especially the angels, are naively rendered, but other elements, such as the stylized leaves, fruits, and flowers, are done with fine artistry. The complex colored drawings were first charted in pencil and then carefully finished in water colors, mainly yellows, blues, greens, and reds. This color work is of a delicate character, corresponding to the sensitive chirography on many of the pages. By means of careful spacing and attention to rules of symmetry, the materials of a fertile imagination are given a final unity, sometimes a compact but never a promiscuous interrelation. In the uncolored draw-

ings, the execution is similarly refined. The leaves and flowers, tree branches, stars, and border designs are tenuous blue-ink traceries, occasionally brightened by touches of red. The buildings, gateposts, boats, arks, and other figures are given solidity by dividing the masses into small, usually triangular sections, arranged to form a harmonious pattern and filled in with fine parallel lines. The purpose seemed to be to glorify familiar objects so that they might stand as counterparts of those in a perfect world. A spirit at once religious and artistic animated the task.

Though the emblems are thus elaborate, the textual portions of the drawings are simply but scrupulously penned. Letters are not floriated, as they are in the Frakturs; capitals are neither scrolled nor colored. Formal prayers, never used in Shaker worship, do not appear, and the verses, while lacking originality, have spiritual integrity. The inscriptions take the form of explanatory legends, religious sentiments (often rhymed), and brief inspirational messages.

Elsewhere noted is the fact that the inspirational arts of the Shakers were rooted in an indigenous culture and were evoked by conditions inherent in their religion. With the possible exception of the medieval-origin arts of the Pennsylvania[15] and Iowa Germans,[16] nothing suggests itself with which to com-

[15] No record or tradition exists, or has come to the authors' attention, to support the theory that the Shakers might have seen, and been influenced by, examples of Pennsylvania Fraktur, or pen-and-brush illumination. A Negro family held meetings in Philadelphia for a short period, but no organized Shaker community existed in the state where Fraktur was practiced. There is the bare possibility, of course, that some member of a Pennsylvania communistic society, familiar with this art, may have joined the Shaker sect and communicated a technique which was later developed by the Believers along independent lines. The argument in the present study seems, however, to make such a theory of origin untenable.

It is possible that such folk art as that represented by the Shaker inspirational drawings and the Pennsylvania Frakturs, as well as by the designs in English crewel-work, ultimately, and by devious channels, has a Far Eastern (Persian or Indian) origin. Because of the extreme simplicity of the conception of ornament, an apparent interrelation in the later primitives is liable to be construed in terms of immediate interderivation.

[16] An interesting parallel to the inspirational experiences of the Shakers is found in The Community of True Inspiration, at Amana, Iowa, which was founded by inspired prophets and whose destinies were largely controlled by instruments (Werkzeuge). This society of Germans, who settled near Buffalo in 1842–43, subsequently moving to Iowa, believed that "if one gives himself entirely, and in all his life, to the will of God, he will presently be possessed by the Spirit of God" (Charles Nordhoff, The communistic societies of the United States . . . , New York, 1875, p. 43). The divine spirit manifested itself in the instruments through various testimonies (Bezeugungen) proceeding "from within," and not "through an external voice into the ears," the revelations being usually accompanied by "violent shaking" or "violent trembling and commotions of the body" (Bewegungen). False inspiration was not unknown.

When two members of the Shaker society visited the "congregation" at Ebenezer in 1846, they noted that "a great part of their spiritual communications is to individuals, where the person is called by his or her name, and then the word is

pare the drawings composing this New York and New England school of folk art, if such it may be called. A distant kinship with illuminated monastic and Persian manuscripts and certain oriental minatures may perhaps be argued. The exalted glimpses of heaven recorded in various ways by the Believers may also recall to some the mysticism of Blake and his inspired visions and emblems of Eden. An animating purpose in all these cases was to enhance the beauty and significance of a document or message by the arts of design and calligraphy. But here the comparison falters. The Shaker compositions were not incorporated into books and scrolls; they accompanied no coherent story or doctrine, celebrated no secular event, and dealt chiefly with emblems. It was the evanescent but distinct spirit of a band of "seekers after light" which these compositions illuminate.

One of the first persons to recognize the "native artistic talent" behind "these strangely fascinating portrayals" was Homer Eaton Keyes, formerly editor of *Antiques*, who, in the issue for November, 1935, wrote in part:

During this period [the 1840's and 1850's] were held ceremonies that could hardly have been seriously enacted except by participants elevated to ecstasy by some form of hypnosis. Such group upliftings were reflected in individual experience. Superterrestrial voices spoke messages to ears attuned to ethereal vibrations, and holy symbols were disclosed to eyes aware of the unseen. The urge to capture such symbols and record their forms and meanings for the benefit of the faithful became so strong as to overcome the prevailing injunctions against pictorial representation of any kind.

As a result we find a considerable group of drawings, some executed simply in line with pen and a bluish ink, others brilliant with clear and shining colors: blues, bright pinks, a lambent yellow, and lively greens. The tints employed are in general much cleaner than those encountered

delivered to them, sometimes it is mortifying and at other times pleasing and comforting." These messages were sometimes accompanied by "rude rhymes" and often associated with visions. One communication, received by the influential instrument Barbara Heinemann, describes a tree "of many branches, leaves, blossoms, and fruits" suggesting the tree of life so often presented to the Shaker visionists. Many inspirational hymns were written by Christian Metz, the venerated prophet and leader of the Inspirationists.

Evidence exists that inspiration in the German society was also expressed in pictorial symbols. The record of the Shaker visit referred to above reveals that "in all their dwelling rooms there is hung upon the side wall, a small frame, about 18 inches high and 10 wide. In this is a variety of rules & orders printed or written, in the form of a cross, and in some of the bottom lines may be seen a heart, a rock and a crown, these little pictures stand as a hyeroglyphicks in the sense of the subject matter to be read" (Elisha Blakeman, "A brief account of the society of Germans, called the True Inspirationists, residing seven miles south east of Buffalo . . . from recollections of Peter H. Long and himself after visiting them in the month of August 1846," New Lebanon, [N.Y.], 1846). See also Shambaugh.

in Pennsylvania *fractur* work or in the illuminated genealogies of New England. Their delicacy and unsullied sweetness suggest that, like Fra Angelico, the Shaker artists were striving to emulate the immaculate and lovely hues of heaven.

In respect both to color and to the fundamentals of technique, the Shaker inspirational drawings are obviously unrelated to the so-called primitive designs produced outside the precincts of Shaker communities. In their arrangement and in the stylizing of their symbols, however, they develop methods and achieve effects that many superficial observers assume to have been derived from Pennsylvania illuminations. With such a judgment I am in complete disagreement. The Shaker fashion of more or less symmetrically balancing elements on each side of a middle line is an almost unconscious and inevitable procedure. The variety obtained within this simple unity may possibly be credited to dim recollections of old sampler patterns. Some of the motives are quite literal renderings of familiar objects, some are simplifications of natural forms expressed in terms virtually universal in folk or primitive art. For others it seems impossible to account except by some theory of automatism. By a like theory must we explain the extreme neatness and deftness of workmanship that distinguished these strangely fascinating portrayals. We may not, of course, deny that their authors were possessed of native artistic talent, perhaps of inherited memories stirred to life by emotional excitement. But that a gift long denied release should at one leap reach so high a level of decorative and technical mastery as we discover in these drawings becomes comprehensible only when we accept some part of the doctrine of inspiration.

In these brief notes I may not even attempt to analyze Shaker drawings in detail or to interpret their symbolism. I shall have fulfilled my intention if I convince my readers that these works of art are worthy of study as independent phenomena, whose resemblance to other primitive creations is not due to any process of imitation but instead is the evidence of a kinship of the subconscious so deeply and universally implanted in humankind as to be almost unaffected either by differences of physical circumstances or by discrepancies of time.

APPENDIXES

BIBLIOGRAPHY

INDEX

Shaker Organization and Chronology

EVERY Shaker community, or society, was divided into two or more family groups, some of which were made up of over a hundred members. Each family also had its own organization: usually two elders and two eldresses, who had general oversight of the unit, especially its spiritual welfare; deacons and deaconesses, who directed secular or industrial affairs; trustees, in charge of finance; and caretakers for the children. The family was an independent economic household. The trustees did business with the families in the same society on the same basis as with other Shaker communities and with the outside world. However, families cooperated and merged their interests in many ways; they worshipped in the same meetinghouse, sent the children to the same communal school, and sometimes shared an office or store for the distribution of goods. Mutual helpfulness prevailed not only among the branches of a single commune but also between one society and another, and time and again a prosperous colony went to the financial aid of one less fortunate. The affairs of the United Society as a whole were regulated by the central ministry of four at New Lebanon, with the aid of subordinate ministries, which had immediate charge of the various bishoprics—groups of two or more societies united for administrative convenience.

The families of each society were named according to their location in relation to the central, or church, order, which was the site of the meeting house. Thus at Hancock and New Lebanon, the organization was as follows:

Hancock and West Pittsfield: Church family, East family, Second family (between the East and Church), South family (or novitiate order), West family, and North family.

New Lebanon: Church family (divided into the First and Second orders, the latter eventually being known as the Center family), the North (or novitiate) order, the East (or Hill) family, the Second family (including an order later

known as the South family), and the Upper Canaan and Lower Canaan families, which were branches of the North.

About 1842, when the mountain meetings were first inaugurated, each society chose for itself, or was given, a spiritual, or inspirational, name by which it was distinguished during the period of the manifestations. The complete list for the eighteen communities existing at the time follows:

New Lebanon, N.Y.	Holy Mount Holy Mount of God	Sabbathday Lake, New Gloucester, or Poland Hill,	
Watervliet, or Niskeyuna, N.Y.	Wisdom's Valley	Me.	Chosen Land
Hancock and West Pittsfield, Mass.	City of Peace	Groveland, N.Y. Union Village, Ohio	Union Branch Wisdom's Paradise
Tyringham, Mass.	City of Love	North Union, Ohio	Valley of God's
Enfield, Conn.	City of Union		Pleasure
Harvard, Mass.	Lovely Vineyard	Whitewater, Ohio	Lonely Plain of
Shirley, Mass.	Pleasant Garden		Tribulation
Canterbury, N.H.	Holy Ground		Vale of Tribulation
Enfield, N.H.	Chosen Vale Chosen Valley	Watervliet, Ohio South Union, Ky.	Vale of Peace Jasper Valley
Alfred, Me.	Holy Land	Pleasant Hill, Ky.	Holy Sinai Plains

Spiritual names were also given to the plots of land reserved for special religious rites during the period of inspiration. Thus, the holy mount at Hancock was called Mount Sinai; at Tyringham, Mount Horeb; at Enfield, Connecticut, the Mount of Olives; at New Lebanon, Holy Mount; at Harvard, Holy Hill of Zion; at Canterbury, Pleasant Grove; and at Enfield, New Hampshire, Mount Assurance. The meetings at Union Village took place at Jehovah's Chosen Square; in South Union, at The Holy Fountain of the Lord Jehovah; and in Whitewater (White Water), at the Chosen Square.

CHRONOLOGY

ca. 1706 The French Prophets open their testimony in England, near London. Allusions to the Prophets of Manchester, England, appear as early as 1712.

1736 Ann Lee born of humble parentage in Toad Lane, Manchester.

ca. 1747 The society popularly known as Shakers, or Shaking Quakers, founded by James and Jane Wardley, formerly of the Quaker faith. Meetings held in Bolton, Meretown (Mayortown), and Manchester.

1758 Ann Lee joins the Shaker society.

1772 Visions and inspirations received by Ann in prison. She is acknowledged as the "Lead" and spiritual Mother of the Shaker sect.

1774 Ann in vision is commanded to go to America.

1776 First settlement made at Niskeyuna (or Watervliet, New York).

1779–80 Revivals at New Lebanon, New York, and vicinity benefit Shaker cause.

1781–83 The mission of Ann and the first elders through New England is accompanied by visions and revelations.

1784 Ann Lee dies at Niskeyuna. James Whittaker, her chief English disciple, assumes leadership, held until his death in 1787. Succeeded by Mother Lucy Wright and Father Joseph Meacham, both of American birth. Besides establishing the society on a firm communal basis, Meacham was supposed to have "introduced the greater part of the spiritualist portion of the Shaker creed and doctrine."

1785–86 First meetinghouse at New Lebanon built. Dedicated January 19, 1786, "the year in which most of the members of the Church were Gathered."

1788 Oral covenant adopted at New Lebanon.

1792 Church established "in gospel order."

1795 Written covenant adopted.

1799–1805 The Kentucky Revival. Conversions to Shakerism result in the eventual establishment of seven societies: two in Kentucky, four in Ohio, and one (short-lived) in Indiana.

1807–37 Period of expansion and steady increase in material prosperity.

Top, left to right:

A Tree of Love, a Tree of life, By holy spirits given.
August 1857.
To help you Thro' this world of strife, And cheer your path to heaven.

Bottom, left and right:

My love is increasing, My love is increasing.
Tho' tempests should beat, and floods may descend,
I'll stand by your side, be your Mother, & friend.

From Mother Ann, To Nancy Oaks. Dictated by Polly Laurence.

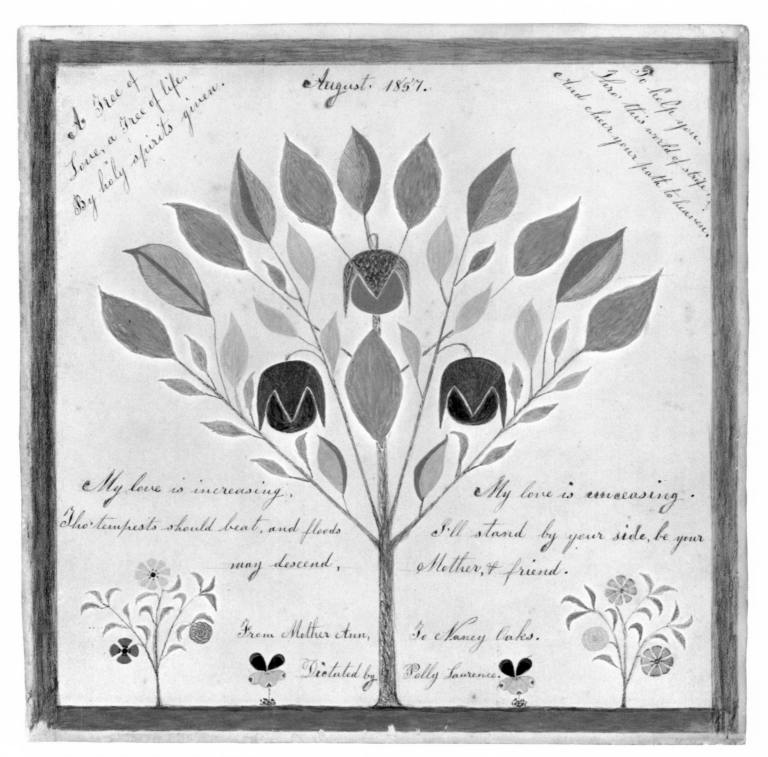

Plate XI. *A Tree of Love, a Tree of Life.* Hancock, 1857. Ink and water color; size: height, 9⁷/₁₆″; width, 9³/₁₆″. (Shaker Community, Inc.)

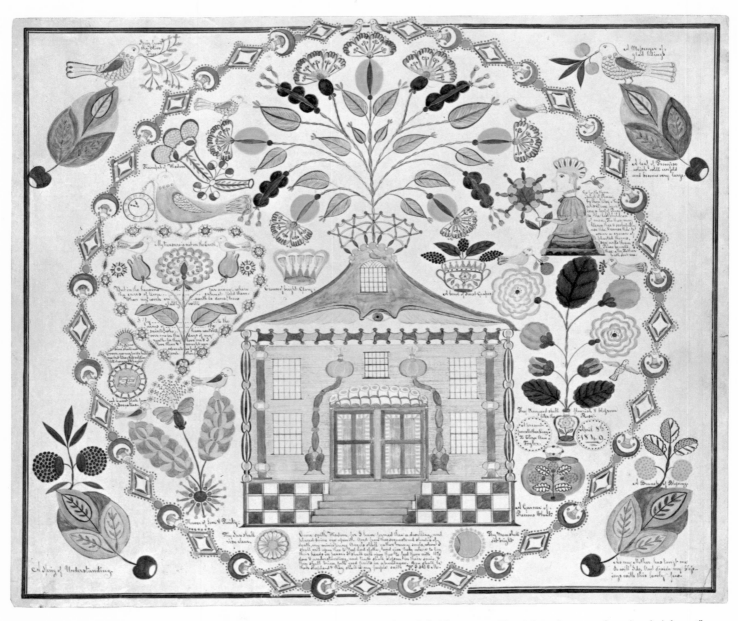

Plate XII. *A present from Mother Lucy to Eliza Ann Taylor.* New Lebanon, 1849. Pale-blue paper, blue ink and water color; size: height, 14″; width, 16⅜″. (Shaker Community, Inc.)

LEFT, TOP TO BOTTOM:

Dove bears:
Sprig from the Olive Tree.
Trumpet of Wisdom

In heart:
My treasure is not on the Earth, But in the heavens far away, where the cares of time cannot find them. When my work on earth is done, how gladly will I fly to the arms of the saints, who have watch'd over me in the days of my youth, for they love me & I love them & nought can separate us from each other.

Left of heart:
My passion shall not govern nor my pride betray me; but like a bold soldier All danger I'll hazard.

In book:
Peace on Earth Good will to man.
A breast plate from Socratees.
Flower of Love & Purity.

Outside circle:
A Sprig of Understanding.

CENTER, TOP TO BOTTOM:

Above house:
Crown of bright Glory.
A bowl of Sweet-Grapes

Beneath house, left and right:
Thy Sun shall rise clear, Thy Moon shall set bright

Center:
Come saith Wisdom, for I have formed thee a dwelling; and placed thine eye upon it. And from thee sequestered shades of death, my ministering Angels shall gather many souls, whom I shall call upon thee to feed and clothe, and give them where to lay their heads in peace. I shall call upon thee to feed them with Wisdom & understanding, and truth shall blossom in their souls, & they shall bring forth good fruits in abundance. You shall be their Shepherd & they shall be my people saith WISDOM.

RIGHT, TOP TO BOTTOM:

Dove:
A Messenger of glad tidings
A leaf of Promise which will unfold and become very large.
Go forth thou Angel of Peace, be thou like Noah's Dove, bearing a leaf of Peace to the last children of men. Tho they may deny thee & scornfully use thee, & cause thee to wear a crown of plaited thorns, say unto them Peace be unto thee, My Father hath sent me.
Thy Vinyard shall flourish & blossom like the Rose.
A present from Mother Lucy to Eliza Ann Taylor. April 8th 1849.
A Garner of Precious Wheat.

Outside circle:
A Branch of Blessing.
As my Mother has taught me So will I do, And divide my blessings with this lovely few.

1837	The revival of 1837 opens with trances and visions among the children of Niskeyuna. First visionary songs.
1838	First inspirational messages received.
1839	Increase in various manifestations and gifts. The service for the dead is changed.
1840	Messages recorded for the first time.
1841	Messages increase in number. The Shakers adopt food and drink reforms. Strange rituals are introduced into the worship of the Believers.
1841–43	Years most productive of inspirational messages. *A Holy, Sacred and Divine Roll and Book* published in 1843.
1842	Meetings on the Sabbath closed to the public. Rituals increase. Departed spirits from many nations visit the Shakers. First ceremonies on the holy mounts.
1842–44	Period in which most of the gifts, or cards of love, notices, presents, and tokens, were received.
1843–44	Period of most of the leaf rewards.
1844	Period of the heart rewards.
1845–47	Period of the seal and the fan rewards.
1845–46	First three major inspirational drawings.
1847	Spirits depart, and manifestations decline in intensity.
1848–49	Four important inspirational designs in color produced.
1849	*Divine Book of Holy and Eternal Wisdom* published by the Shakers.
1851–57	Period in which most of the larger designs in color were produced. Five documents in 1854.
ca. 1854	Mountain meetings discontinued. Few messages received after 1855.
1859	Year of the last drawing documented in the text.
1867	Communications, songs, visions, notices, and cards intermittently received until this date.

APPENDIX II

Check List of Shaker Inspirational Drawings

Compiled by Susan Terdiman, in cooperation with Mrs. Faith Andrews

THIS list includes all the extant Shaker inspirational drawings that could be located, but it does not claim to be definitive. Information about any additional drawings is welcome. The listings are in alphabetical order, according to their present location. Italics indicate direct quotations from the drawings. Those drawings which are discussed and illustrated in the main text are simply noted by title and figure or plate number.[1]

[1] Thanks are due to all those who, through their willingness to share information and help in the research, have made this list possible. Mr. Eugene M. Dodd of the Shaker Community, Inc., Hancock, Massachusetts, and Mr. Robert F. W. Meader of the Shaker Museum, Old Chatham, New York, have been most helpful in compiling the check list, as have the following individuals and institutions: The Abby Aldrich Rockefeller Folk Art Collection, Williamsburg, Va.; American Antiquarian Society, Worcester, Mass.; American Society for Psychic Research, New York City; The Berkshire Athenaeum, Pittsfield, Mass.; Buffalo and Erie County Library, Buffalo; Cincinnati Art Museum, Cincinnati; Connecticut State Library, Hartford; The Darrow School, New Lebanon, N.Y.; The Dayton and Montgomery County Public Library, Dayton, Ohio; Duke University Library, Durham, N.C.; The Filson Club, Louisville, Ky.; Fruitlands Museums, Harvard, Mass.; Mrs. Edith Gregor Halpert, New York City; The Harrodsburg Historical Society, Harrodsburg, Ky.; Hofstra University Library, Hempstead, Long Island, N.Y.; Mr. Robert Jones, Lebanon, Ohio; Mr. William Lassiter, Albany; The Library of Congress, Washington, D.C.; Nina Fletcher Little, Brookline, Mass.; Margaret I. King Library, University of Kentucky, Lexington, Ky.; The Metropolitan Museum of Art, New York City; Milwaukee Art Center, Milwaukee; Museum of American Folk Art, New York City; Museum of Fine Arts, Boston; New Hampshire Historical Society, Concord, N.H.; The New-York Historical Society, New York City; The New York Public Library, New York City; New York State Library, Albany; The Ohio Historical Society, Columbus, Ohio; Professor Elmer R. Pearson, Chicago; The Philadelphia Museum of Art, Philadelphia; Shaker Historical Society, Shaker Heights, Ohio; Shaker Museum, Auburn, Ky.; The Shaker Museum, Sabbathday Lake, Poland Spring, Me.; Shaker Village Work Group, New Lebanon, New York; Shakertown at Pleasant Hill, Harrodsburg, Ky.; Shelburne Museum, Shelburne, Vt.; Smithsonian Institution, Washington, D.C.; The State Historical Society of Wisconsin, Madison, Wis.; The State Library of Ohio, Columbus, Ohio; Syracuse University Library, Syracuse, N.Y.; Mr. Charles Thompson, Canterbury, N.H.; Western Kentucky University, Bowling Green, Ky.; The Western Reserve Historical Society, Cleveland; Whitney Museum of American Art, New York City; William Henry Smith Memorial Library of the Indiana Historical Society, Indianapolis; William L. Clements Library, The University of Michigan, Ann Arbor, Mich.; Williams College Library, Williamstown, Mass.

THE ABBY ALDRICH ROCKEFELLER FOLK ART COLLECTION, WILLIAMSBURG, VIRGINIA
A Present from Mother Ann to Mary H. Fig. 7.

THE BERKSHIRE ATHENAEUM, PITTSFIELD, MASSACHUSETTS
Symbolic drawing. *From Holy Mother Wisdom to Betsey Bates.* Script messages. Figures include *Wings of Holy Wisdom, Wings of the Heavenly Father,* birds, trees, flowers, heart, clock, "machines." Mount Lebanon, *April 11, 1847.* Blue ink on white paper with decorations in blue and brown ink; size: height, 16″; width, 21″. Similar to Figs. 10, 11, 13, 15, 17.

FRUITLANDS MUSEUMS, HARVARD, MASSACHUSETTS
Symbolic drawing. *Wings of Holy Mother Wisdom. Wings of the Heavenly Father.* Script messages. Figures include clock, heart, birds, trees, flowers, moons, "machines." Place unknown, *1846.* Light-blue ink on white paper, with one detail in red; size: height, 19″; width, 27″. Similar to Figs. 10, 11, 13, 15, 17.

MRS. EDITH GREGOR HALPERT, NEW YORK CITY
The Roll That De Holy Mudder Send. Communication from a "spiritual Indian."

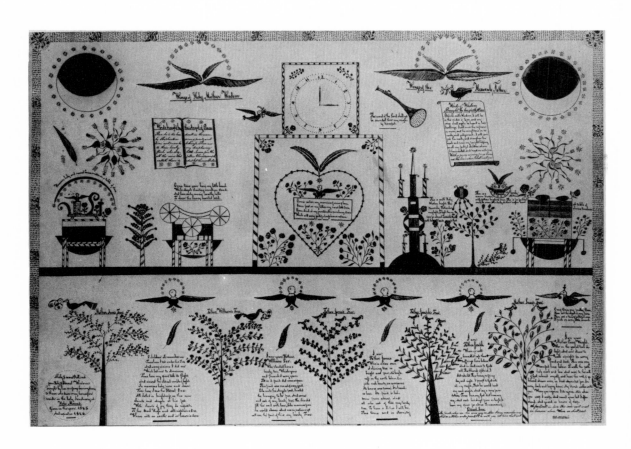

Inscription in pigeon English and "Indian" code symbols and figures. Pen and ink, with touches of color; size: height, 18″; width, 24″.

THE HENRY FRANCIS DU PONT WINTERTHUR MUSEUM, WINTERTHUR, DELAWARE
Leaf sketches. Fig. 4.

NINA FLETCHER LITTLE, BROOKLINE, MASSACHUSETTS
"Geometric" drawing. *Holy Wisdom's Word written within Her Golden Wheel. From Holy holy Wisdom to Her beloved ones Eldress Ruth & Sister Asenath.* In the center of the paper is a representation of the golden wheel divided into eight numbered sections, on which are script messages. At top, bottom, and sides are religious comments in script, which refer to the receiving of this message. *Holy Mount* (New Lebanon), *Jan. 30th 1844.* Script in ink. Four sections of the wheel and a center circle painted golden yellow; size: height, 17″; width, 12″. Instrument, Marilla Fairbanks (signed).

THE NEW YORK PUBLIC LIBRARY, NEW YORK CITY
Heart. *The Word of the Holy, Heavenly Father, To a Child of his Love.* Script message and figures on recto and verso. Figures include rose, star, birds, candles, book, clock, harp. Place unknown, *April 14th 1844.* Size: height, 4″; width, 4″. Similar to Fig. 6. (Shaker no. 53.)
Heart. *The Word of the Holy Heavenly Father To a Child of his Delight. Maria De Witt.* Script message and figures on recto and verso. Figures include birds, flowers, trees, stars, crown. Place and date un-

known. Size: height, 4″; width, 4″. Similar to Fig. 6. (Shaker no. 53.)
Seven sheets of drawings, once part of a roll. Order not clear. All have a double line *ca.* ³/₁₆″ wide down the center. Place and date unknown. (Shaker no. 106.)
1. Figures include a ladder (?), *Gun, Tomehack,* spear (?), stones (?). Black ink on white ruled paper; size: height, 13″; width, 4″.
2. Figures include *Stones, Pincers, Broom, Spear, Axe, Traitor* (a semirectangular figure). Black ink on white ruled paper; size: height, 13″; width, 4″.
3. Figures include *Whips, Tongs, Broom,* spear (?), stones (?). Black and blue ink on white ruled paper; size: height, 13″; width, 4″.
4. Figures include four *Serpents, Shuvel,* ladder (?), spears (?) and knives (?) cutting the serpents. Black ink on white ruled paper; size: height, 13″; width, 4″.
5. Figures include *Hamer, Hetchel* (?), *Helcthel* (?), spears (?), stones (?). Black ink on white ruled paper; size: height, 13″; width, 4″.
6. Figures include *Walls of Zion, Flowers, Lamp, Path, Shiney Angel,* spears (?), insect or star-shaped designs, stones (?), long black-outlined rectangle. Black ink on white ruled paper; size: height, 26″; width, 4″.
7. Figures include path, leading to "brick" *Walls of Zion, Shiney Angel, Fruit trees,* flowers, dots. Probably was at end of roll. Blue ink on white ruled paper; pale-blue paper pasted on back; size: height, 12³/₈″; width, 4″.
Words of the Savior. Cutout and foldout message and drawings; 30 numbered

pages. Script message and line figures on recto and verso. Figures include crosses, arrows, trees, hearts, and cryptic "code" figures. Cut and folded so that crosses and an arrow fit into page like a puzzle. Place unknown, *May 2nd 1843*. Black ink on white ruled paper; size folded: height, 3½″; width, 4½″. (Shaker no. 102.)

To the Instrument Writers. Elaborate cutout and foldout message; 20 pages. Messages in script and code; geometrical and line figures on recto and verso. Figures include geometric forms, letters, dots, a ship (?), X's, in cryptic arrangement. Place and date unknown. Black ink on white ruled paper; size folded: height, 3½″; width, 4½″. (Shaker no. 103.)

Words to the Watchmen. Cutout and foldout message; 18 pages. Messages in script and code; cryptic line figures, some in geometric forms, and letters on recto and verso. Place and date unknown. Black ink on white ruled paper; size folded, height, 3½″; width, 4½″. (Shaker no. 104.)

THE OHIO HISTORICAL SOCIETY, COLUMBUS, OHIO

Tree of Heaven—Instrument James Mott. Diagram of seven concentric circles on rectangular paper. Explanatory script in circles. Innermost circle represents *The Throne of God, and the center of the Heavens,* and the outermost circle represents in part *the boundless space that surrounds the City of the Saints.* Scriptlike figures in corners of page. Mount Union (Enfield, Conn.), 1844. Blue, black, and brown ink on a white cloth-type material; size:

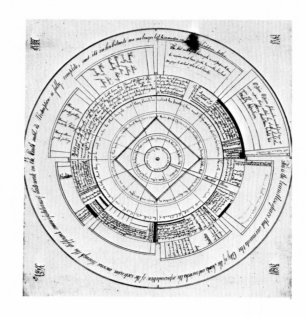

height, 19½″; width, 23″. (United Society of Believers [Shakers] Papers, Collection 119, Box 5, Manuscripts Department.)

PROFESSOR ELMER R. PEARSON, CHICAGO

No Cross no Crown. Very stylized drawing with large central cross, birds, flowers, waves, rocks. Some script. Watervliet, *ca.* 1880. Pen and ink with water-color wash; size: height, 27¾″; width, 21¹³/₁₆″. Instrument, *By Eugene B. Cunningham* (signed).

PHILADELPHIA MUSEUM OF ART, PHILADELPHIA

Leaf. *A Word of Notice, love & blessing, From Abraham of Old, To Sister Asenath.* Script message and figures of stars, recto and verso. New Lebanon (?), *March 2nd 1845.* Paper cutout in shape of olive leaf; light green recto, white verso; ink; size: height, 8″; width, 4⅛″. Similar to Fig. 5. (Accession no. 63-160-199(5).)

Leaf. *A Word of Love and Blessing. From Abraham of Old, The Father of the Faithful, To Cyntha Hamlin.* Script message and figures of stars, recto and verso. Place unknown, *June 12th 1844.* Paper cutout in shape of olive leaf; light green recto, white verso; ink; size: height, 6¾″; width, 3⅞″. Similar to Fig. 5. (Accession no. 63-160-199(4).)

Leaf. *A Word of Love and Blessing, From Abraham of Old, The Father of the Faithful, To Ursula Bishop.* Script message and figures of stars, recto and verso. Place unknown, *June 12th 1844.* Paper cutout in shape of olive leaf, light green recto, white verso; ink; size: height, 6⅝″; width, 3⅞. Similar to Fig. 5. (Accession no. 63-160-199(3).)

Leaf. *A Word of Love and blessing, From Abraham of Old, The Father of the Faithful, To Jane Smith.* Script message and figures of stars, recto and verso. Place unknown, *June 12th 1844.* Paper cutout in shape of olive leaf; light green recto, white verso; ink; size: height, 6⅝″; width 3⅞″. Similar to Fig. 5. (Accession no. 63-160-199(2).)

Leaf. *A Word of Love and Blessing, from Abraham of Old, The Father of the Faithful, To Betsy Darrow.* Script message and figures of stars, recto and verso. New Lebanon (?), *June 12th 1844.* Paper cutout in shape of olive leaf, light green recto, white verso; ink; size: height, 7⅜″; width 4¼″. Similar to Fig. 5. (Accession no. 63-160-199(1).)

Inspirational drawing. Symbolic designs on recto. On verso: *A sacred Sheet sent from Holy Mother Wisdom, by her Holy Angel, of many Signs. Received January 25th, 1843. Written in the first Order on the Holy Mount for Elder Sister Betsy Darrow Febʳ 1ˢᵗ 1843.* New Lebanon, 1843. Pen and blue ink; size: height 12¾″; width 15¾″. Probable instruments, Semantha Fairbanks and Mary Wicks. Similar to Figs. 1 and 2. (Accession no. 63-160-4.)

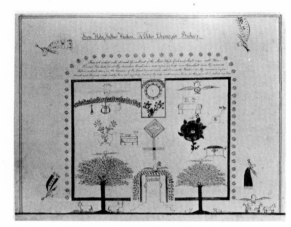

Inspirational drawing. *From Holy Mother Wisdom. To Elder Ebenezar Bishop.* Script message with symbolic figures within rectangle below. Figures include clock, chair, rose, harp, birds, trees, and angels. Animals and horse-drawn cart below. Caption on door reads *Come thou Blessed.* New Lebanon, date unknown. Pen and blue ink; blue, yellow, red, and rose wash; size: height, 11⅜″; width, 14½″. Somewhat similar to Plate VIII, with rectangle in center rather than circle. (Accession no. 63-160-6.)

Diagram. *The Holy City.* Circle within rectangular frame, divided into numbered sections. Gates labeled: *Gate of Honesty, Gate of Patience,* etc. Mount Lebanon, March 16, 1843. Pen and red ink; rose, yellow, green, and black wash; size: height, 31″; width, 24¾″. Probable instru-

ment, First Father Adam. (Accession no. 63-160-5.)

Symbolic design. Fig. 14. (Accession no. 63-160-3.)

From Holy Mother Wisdom to Hannah Ann Treadway. Fig. 15. (Accession no. 63-160-2.)

Wings of Holy Wisdom. Fig. 17. (Accession no. 63-160-1.)

SHAKER COMMUNITY, INC., HANCOCK, MASSA-CHUSETTS

Sacred Sheet. Fig. 2.

Mother Ann's Word to her little child Elizabeth Cantrell. Fig. 3.

Heart gifts, or rewards. Fig. 6.

From Holy Mother Wisdom to Sarah Ann Standish. Fig. 9.

The Tree of Light or Blazing Tree. Plate I.

A Type of Mother Hannah's Pocket Handkerchief. Plate II.

Floral wreath. Plate III.

A gift from Mother Ann to the Elders at the North Family. Plate IV.

Heavenly tree. Plate V.

A Bower of Mulberry Trees. Plate VI.

The Tree of Life. Plate VII.

From Holy Mother Wisdom. To Eldress Dana or Mother. Plate VIII.

An Emblem of the Heavenly Sphere. Plate IX.

Basket of apples. Plate X.

A Tree of Love, a Tree of Life. Plate XI.

A present from Mother Lucy to Eliza Ann Taylor. Plate XII.

Heart. *The word of the Holy one of Israel Amy Reed.* Script messages and figures. New Lebanon, *April 2nd 1844.* Blue ink on pink paper; size: height, 4″; width, 4″. Similar to Fig. 6.

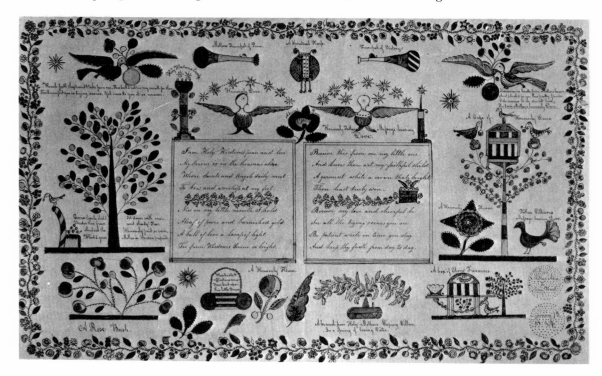

Heart. *The word of the Heavenly Father Mary Hazzard.* Figures and script messages. New Lebanon, *April 14 1844.* Blue ink on pink paper; size: height, 4″; width, 4″. Similar to Fig. 6.

Heart. *The Word of the Holy Heavenly Father to a Babe of His Love Emma Jane Blanchard.* Script messages and figures. New Lebanon, date unknown. Blue ink on blue paper; size: height, 4″; width, 4″.

Leaf. *A word of Notice, love and blessing. By Rufus Bishop.* New Lebanon, 2/28/1845. White paper, coated bright green on one side; writing in blue ink; size: height, 8¾″; width, 4⅜″. Similar to Fig. 5.

Symbolic design, with no writing. Place and date unknown. Blue-ink drawing on white paper; size: height, 7⅞″; width, 13¹⁄₁₆″. Similar to Figs. 1 and 2.

THE SHAKER MUSEUM, OLD CHATHAM, NEW YORK

Symbolic drawing. *From Mother Ann to Amy Reed.* Messages in script. Two rectangles in center. Figures include doves, trumpets, trees, flowers, bird cage. Mount Lebanon, *January 7th 1848.* Design in many colors on white paper with a slight bluish cast; size: height, 9¾″; width, 15¾″. Probable instrument, Sister Eleanor Potter.

Fan. *Words from Mother Ann.* Script messages and figures on recto and verso. Figures include lamb, bird, flowers, tree, moon. Mount Lebanon, *January 30th, 1847.* Gray-white paper, black ink, illuminations pricked out in red and black; size: total height, 6¹⁵⁄₁₆″; maximum width of fan-shaped part, 5⁵⁄₁₆″.

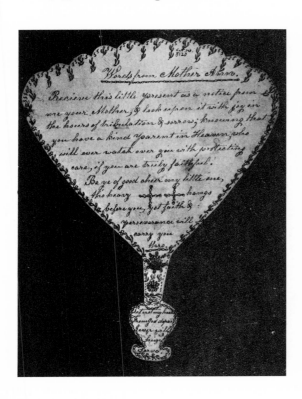

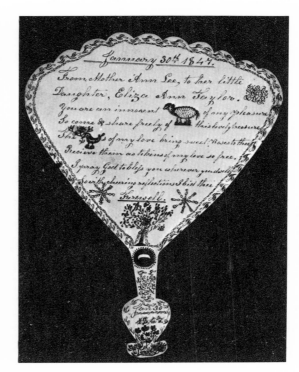

Spirit message in script. *This is the cross/ Our Saviour Bore. Amy Reed.* Figures of stars (?). Mount Lebanon, *January 1st 1845.* Off-white paper, dark-blue ink; size: height, 5½"; width, 4½".

Spirit message in script. *A Cup of Blessing & a little White Dove, Given to Mary Hazard from Eldress Ruth's Treasure by Eldress Betsy Hastings, With a kiss of her sweetest love.* Mount Lebanon, *June 2nd 1-8-5-0.* Commercial sheet of pale-blue paper, dark-blue ink; size: nearly square, 7¾".

Spirit message in script, with music in the Shaker "letteral notation." *Given by Sister Semantha Fairbanks for M[ary] H[azard].* Mount Lebanon, *March 1st 1865.* White commercial note paper, dark-blue ink; size: height, 8"; width, 5". Probable instrument, Semantha Fairbanks.

Large geometric drawing, written on recto and verso in both regular script and script which purports to be in "Indian" writing. In pencil, on recto: *Seen June 9, 1843. Copied June 14. Word of the Saviour.* On recto, eleven circular forms with flower-like figures. On verso, circular treelike and flower-like forms. Mount Lebanon, 1843. Dark-blue ink on white paper; size: height: 16¹⁄₁₆"; width, 32".

Geometric drawing, unifaced. Central design of concentric circles and sunbursts, framed by a rectangle of a mixture of regular script and "Indian" writing. On verso in pencil, *Seen June 4th, 1843, copied June 9. Done by an angel.* Mount Lebanon, 1843. Dark-blue ink on white paper; size: 16⅛" square.

THE SHAKER MUSEUM, SABBATHDAY LAKE, POLAND SPRING, MAINE
From Isreal Hammond. To Molly Smith. Script

message on rectangular paper. In center of page is a verse enclosed in a circle of leaflike forms. Figures in the circle include two birds, a tree, a star (?). Place and date unknown. Size: height, *ca.* 10"; width, *ca.* 8".

Mother's Promise to her Instruments. Inspirational message in semipictorial design. Script messages; figures include geometrical shapes, house, trees, orchard, sun, moon, stars. Canterbury, *Seen by an Instrument of Mortal Clay January 12th Sab P. M. Received and copied following day* (no year). Size: height, 20½"; width, 15¾".

A gift from Mother Ann. Fig. 12.

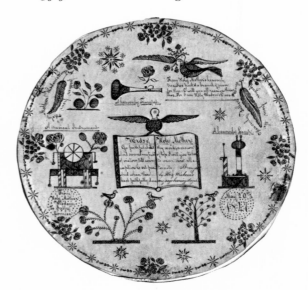

SHAKER VILLAGE WORK GROUP, NEW LEBANON, NEW YORK
Circular drawing. *Words of Holy Mother. From Holy Mother Wisdom, To Sally Lomise.* Starlike border. Script messages. Figures include doves, quills, flowers, trees, "machines." Harvard (?), *May 20th 1847.*

Dark-blue imprint on light-blue background; size: 6½″ diameter. Instrument, Sister Sally Lomise. Similar to, but simpler than, Fig. 18.

Spirit drawing in varied styles of block lettering, in what appears to be a code. It has nine lines and is headed: *H / REAR / AMERIC PIN UST.* Two footnotes in script, one for letters *LS: The visionist said was to be hung up.* and one for letters *KG: This the visionist called King George.* Place and date unknown. Blue ink; size: height, 9½″; width, 7¾″.

Cutout and foldout message and drawing. *To the Instrument writers.* Scattered lettering in varied styles and bizarre forms, some resembling human outlines. A code statement in script. Script and drawings on recto and verso. Holy Mount, 1843. Size, unfolded: height, 13″; width, 8″ in places, 11″ other places; folded: height, 3½″; width: 5″.

MR. CHARLES THOMPSON, CANTERBURY, NEW HAMPSHIRE

Sacred Sheet. Fig. 1.

Inspirational drawing. Figures include two

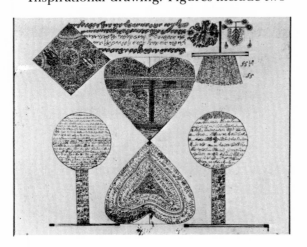

hearts, point to point, circles atop columns, and a square, all filled with flowery forms and code (?) script. Place and date unknown. Pen and ink; size: height, 15″; width, 16¼″.

Inspirational drawing. Large central square filled with geometric figures, numbers, and script, some legible, some in code (?). Border includes flowery figures, lines, a dark triangle, and a labeled *Wall of Zion* with *Watchmen* atop it. Place and date unknown. Pen and ink with some red, green, and black painted areas; size: height, 17½″; width, 20″.

THE WESTERN RESERVE HISTORICAL SOCIETY, CLEVELAND

Circular drawing. *Come lovely child, rejoice with me. From Holy Mother Wisdom To Grove Blanchard.* Floral border. Script messages. Figures include *The Heavenly Father's Wings,* doves, flowers, trees. Place unknown, *May 20th 1847.* Blue ink on blue paper; size: 6⅝″ diameter. Similar to Fig. 18.

Inspirational writings and drawings. Manuscript, pages numbered 27 through 41. Mount Lebanon, 1842–1859. Size of pages: 22½ cm. Instrument, Miranda Barber.

Page 27. *The Following is copied from a book of prophetic signs written by the Prophet Isaiah June 1843.* All script.

Page 28. *How beautiful art thou clothed O Zion!* Script message. Pictured: *Pillar of Fire,* rust red; *Eternal Brightness,* a wreath of tiny flowers; petals are blue outline with red edge.

Page 29. *Peace on Earth and good will to Mankind. The Four Doves of Heaven, Bringing a blessing to Earth.* Pictured:

center circle with alternating quarters of blue and rose. Four doves in blue ink carrying *Grapes*, red with bluish-green leaves; *Leaves*, shaded blue-green; *Grain*, yellow; *Fruit*, blue, with red and green.

Page 30. *O Zion, Zion, the day of thy trial hath come!!!* Script message in blue ink. Pictured in many colors: human figures, a cross, crucifixion of a female figure, dove, lamps, hands.

Page 31. *Some scourged and cast into Prison for their faith.* Pictured: rectangular prison, bars and hands with whips in brown ink; birds in blue ink holding sprays of red and green fruit (?).

Page 32. *Zion is ravished continually by the unclean.* Script messages. Pictures in red, blue, and yellow include doves, hands, men driving horse-drawn carriages, candle.

Page 33. *Those that stand cast into dun-*

geons; but are not forsaken. Pictured: rectangle with four brown corners labeled *Dungeons. Dungeons.* In central cross a bird, *I Am with you,* and a *Candle of the Lord* in red, blue, and yellow.

Page 34. *A Hand streached out in the Firmament above, and a loud Voice declaring Judgement. The Voice Rolling. My Time Hath Come.* Pictured: black hand, surrounded by scalloped rectangles in many colors.

Page 35. *The Beasts of the Fields and Forests.* Script message. Pictured: thirty-eight named animals in blue-ink lines, with some in various solid colors.

Page 36. *And from the Stones of their Walls shall come forth a Voice.* Script message in blue and brown ink. Pictured: *Rock[s]*, lavender; *Mountains*, blue and blue-green; *Beam[s]*; blue ink; *Wall*, blue ink.

The Beasts of the Fields and Frests, both tame and wild will be driven together and will bat peace with each other, because of the destruction that will come on the Earth; for it will come in the latter days; and they will murmer and rebel against mankind; and shall not be Tamed by man for a season.

Page 37. *And showers of blood will fall from Heaven.* Script message. Pictured: *Showers of Blood,* reddish brown; *Rivers of Blood,* reddish brown; fish, blue-ink lines; sea (?), blue; coral (?) rose.

Page 38. *And there will be terrible winds in the earth and fire and hail, and dreadful earthquakes.* Pictured: Blue circle outline; *Hail,* dark blue; *Earthquakes,* inked blue lines; *Fire,* rose red; *Wind,* dark-brown semicircular scallops.

Page 39. *The Sun clothed in Sackcloth and the Moon in Scarlet!!!* Script message. Pictured: small circle, rust red; large circle, black.

Page 40. *Awful judgements without ceasing pouring forth.* Script message. Pictured: circle, half brown, half pale rust red; crescent, brown.

Page 41. *Wisdom calls on the Children of Zion to sound the Gospel Trumpet to distant Nations.* Script message. Pictured within ring of stars: circle, top half, butter yellow; bottom half, rust brown; four trumpets, sky blue.

Heart. *The Word of the Holy Heavenly Father, To a Son of his Delight and Pleasure. Daniel Boler.* Script message and figures on recto and verso. Figures include sword, crown, birds, flowers, trees, *The Record of Holy Wisdom.* New Lebanon, *April 23rd 1844.* Blue ink on white paper; size: height, 4³/₈"; width, 4¹/₂". Similar to Fig. 6.

Heart. *The Word of the Holy Holy God of Israel, To a Servant of his Choice. Philemon Stewart.* Script message on recto and verso. Figures on verso include lamps, harp, birds, flowers. New Lebanon, *April 3rd 1844.* Blue ink on blue paper; size: height, 4³/₈"; width, 4¹/₂". Similar to Fig. 6.

Heart. *The Word of the Almighty Jehovah,* who ruleth above & below. To his Al Sign, *Te re Jah. Nathan Williams.* Script message and figures on recto and verso. Figures include stars, *shield,* crown, birds, flowers. Place and date unknown. Dark-blue ink on yellow paper; size: height, 4³/₈"; width, 4¹/₂". Similar to Fig. 6.

Heart. *The Word of the Holy Heavenly Father, To a Child of his Love. Betty Mixer.* Script message and figures on recto and verso. Figures include fan, birds, trees, stars, crown, flowers. New Lebanon, date unknown. Blue ink on white paper; size: height, 4³/₈"; width, 4¹/₂". Similar to Fig. 6.

Heart. *The Word of the Holy Heavenly Father, To a Child of his Love. Cyntha Hamlin.* Script message on recto and verso. Figures on verso include harp, birds, trees, flowers, trumpet. Place and date unknown. Blue ink on white paper; size: height, 4³/₈"; width, 4¹/₂". Similar to Fig. 6.

Heart. *The Word of the Holy Heavenly Father, To a little Child of his Love. A Child of my Holy Kingdom,* with initials *LB* on verso. Script message on recto and verso. Figures on verso include stars, lamps, flowers, harps. Place unknown, *April 1844.* Blue ink on blue paper; size: height, 4³/₈"; width, 4¹/₂". Similar to Fig. 6.

Inspirational drawings. Manuscript, eight pages, unpaginated. Place unknown, 1843 (?). Ink and water color (?); size of pages: 18 × 21 cm.

1. First page headed *Father William.* All script message, nine paragraphs.

2. Large center circle design; eight other geometrical designs around borders; block letters, geometrical figures, script words: *Ask Seek Cry Watch Strive Pay Weep,* within central area of drawing.

3. Large solid circle in center of drawing crossed diagonally by two swords (?). Text on four sides of circle; one side reads: *This was seen on the south side of the sun June 7 1843.*

4. Drawing with wavy lines coming from large black circle slightly off center. Animals representing *hatred, Strife, Discord, self righteous.* Snakes (?) representing *pick flaws* and *Contention.* Also a *Tree of true union.*

5. Script and diagrams of a Shaker garden (?). Heading on one half: *This roll was seen over the South House held by two Angels January 1840 The Word of the Lord.* followed by a poem in script and some code writing. Other half of sheet headed *South House July 1842,* includes *This is and Orchird,* and *Various kinds of fruits* with diagrams of gardens.

6. Drawing of geometrical figures, block letters, numbers and dots, apparently in code.

7. Drawing of geometrical figures, block letters, numbers and dots, apparently in code. Large central square and crosses.

8. Last page, headed *WORD OF GOD.* Message in script and block letters. At bottom of page: *JUDGMENTS. TRIBULATION. SUFFERINGS. PERSECUTION. Mercy; Charity; Justise; Love; May 1st 1843.*

Heart. *The Word of the Holy Heavenly Father To a Child of his Love. Mary Ann Mantle.* Script message and figures on recto and verso. Figures include birds, flowers, lamps, harp, sword, stars. Place and date unknown. Blue ink on blue paper; size: height, $4^3/_8''$; width, $4^1/_2''$. Similar to Fig. 6.

Inspirational drawing. *A Breastplate from Holy Mother. Joanna Kitchell* in diamond, lower left corner. Script messages and figures within and around large central circle made up of floral forms. Figures include birds, flowers, *Fruit of self-denial, A Cup of Holy Water, From Father James, A Present from the Natives brought by one of Father Issachar's Tribe.* Place unknown, *Nov. 19th 1848.* Ink and water colors on pale-blue paper; size: 9″ square. Figures similar in style to Fig. 7.

Symbolic drawing. *From Holy Mother Wisdom to Joanna Kitchell.* Script messages, and a song in Shaker musical notation. Large central heart inscribed in a square. Figures include *Wings of Holy Wisdom. Wings of the Heavenly Father. Flowers of Tribulation,* birds, flowers, trees, "machines," moons, *Holy Wisdom's Trumpet.* Place unknown, *September 11th 1845.* Ink; size: height, 15″; width, $20^1/_2''$. Similar to Figs. 10, 11, 13, 15, 17.

Inspirational drawing. *A Golden Crown of Comfort and Rest from heavy Sufferings. Given by Father William To Elder Rufus Bishop. Brought and Revealed By James Wardley Junior.* Three columns of script

messages and poems with large central crown of flowers and stars. On verso: *instrument Phebe A. Smith. Watervliet (?), Dec' 16. 1846.* Ink and water color. Size: height, 13½"; width, 16¾".

Inspirational drawing. *City of Peace.* Messages in "code" writing and script. Figures include large central tree, pillars, and circles containing names of virtues (e.g., *simplicity, prudence*). Ink and water color on manila-type paper backed with pink cloth. *Drawn and written by Elder Joseph Wicker. Hancock, Nov. 1844.* Size: height, 32"; width, 27½".

A Present from Holy Mother to Brother John C. Fig. 8.

From Holy Mother Wisdom to Eliza Sharp. Fig. 10.

From Holy Mother Wisdom to Daniel Boler. Fig. 11.

Holy Mother Wisdom's Wings. The Heavenly Father's Wings. Fig. 13.

From Father Joseph, to Eliza-Ann Taylor. Fig. 18.

LOCATION UNKNOWN

Card of love, or reward. Two "palms," round figures with stems, made up of leaflike designs. Script and "code" messages. *These Palms were placed in the hands of Elder Sister Marrilla Fairbanks. Holy Mount* (New Lebanon) *1ˢᵗ Order,* date unknown. Ink; size: height, 4¼"; width, 6¹⁄₁₆".

Card of love, or reward. Perhaps reverse side of preceding figure. A fan made up of leaflike designs and "code" letters. *From your loving Mother Ann To Elder Sister Marilla F.[airbanks].* Script message. New Lebanon, *Feb 6ᵗʰ 1845.* Ink; size: height, 4¼"; width, 6¹⁄₁₆".

A Fruitbearing Tree. A Cedar of Paradise. Large central tree, similar in style to that of Plate I. Bed of flowers at the base of the tree. Long script message beneath tree and flowers. *And this emblem is now given (Dec. 1846) by Mother Ann as a token of her love and remembrance to Clarissa Veddar.* Watervliet, 1846. Ink and water color; size: height, 26"; width, 17". On verso: *Instrument, Phebe A. Smith.*

Leaf gift, or reward. Fig. 5. *Little tokens of love, love & blessing.* Fig. 16.

Bibliography

THE books and pamphlets listed here offer a reasonably comprehensive account of the history and socioreligious doctrines of the Shakers. Emphasis is laid on studies of their culture during periods of revival. Certain items, like the "Millennial Laws," the "Holy Laws of Zion," and the *Testimonies* of 1816, were secret documents originally held by the elders. Many others were private papers, sometimes copied but never published and intended as family records or memorandums of individual experience.

The sources are organized into two sections. In section I are the works of the Believers, with subdivisions for manuscripts including hymnals and song books and for printed materials. In section II are the other sources relevant to the present study, with subdivisions for the observations of non-Believers and for sources on religious art, automatic writing, and spirit drawing.

Place of origin and present location of some of the manuscripts are not known. A known place of origin is indicated by the place name in the citation. Doubtful places of origin are queried. Manuscripts in The Edward Deming Andrews Memorial Shaker Collection in The Henry Francis du Pont Winterthur Museum are identified by Andrews Coll.

I. WORKS OF BELIEVERS

Manuscripts

Inspirational communications; records of mountain meetings and other ceremonials; arranged chronologically and alphabetically within the same year

"A true record of sacred communications; written by divine inspiration; by the mortal hands of chosen instruments; in the church at New Lebanon." 11 vols., 1838–42.

"Inspired message concerning injurious & unprofitable books. Also rebuking an undue thirst for knowledge of worldy science." New Lebanon, [N.Y. ?], 1840.

"A record of messages and communications given by divine inspiration in the church at Hancock." 1840 (Andrews Coll.).

Stewart, Philemon. "A general statement of the holy laws of Zion. With a supplement to the holy laws of Zion, and several communications regarding the same." New Lebanon, [N.Y.], 1840 (Andrews Coll.).

Book of messages, bound by Joseph Wicker, beginning March 4, 1841. No title. Hancock, [Mass.]

Leonard, William. "Copy of the record of divine instructions from our blessed & Holy Mother Wisdom. To the beloved brethren and sisters in the United Society at Harvard. . . ." Harvard, [Mass.], 1841.

———. "Lives and sufferings of Christ our holy Saviour and our blessed Mother Ann. Given by inspiration. . . ." Harvard, [Mass.], 1841.

"Prophetic revelations from the ancient prophets. Given by the inspiration of their spirits, as testimonies of the work of God in the present dispensation, & connected with all the preceding degrees thereof; containing also prophetic warnings & predictions of the work of God to the end of the probationary state." 3 vols. New Lebanon, [N.Y.], 1841.

"A record of communications from the spiritual world for Albert Battles. Given by divine inspiration, First family, City of Love." Tyringham, [Mass.], 1841 (Andrews Coll.).

Vedder, Polly. "A spiritual journal. In which, is recorded many of the beautiful & precious gifts & presents we have received from our heavenly parents, in the world of spirits." Watervliet, [N.Y.], 1841.

"The word and work of Holy Mother Wisdom. To which is added words of our Savior and Mother Ann Lee Father Joseph Meacham & Mother Lucy Wright. Father Job Bishop and Mother Hannah Goodrich as her witnesses at Holy Ground. . . ." Canterbury, [N.H.], 1841.

Inspirational messages and communications. No title. Hancock, [Mass.], 1841–42.

"A record of messages and communications given by divine inspiration in the Second family, at Pittsfield." 1841–43 (Andrews Coll.). West and East family messages and communications are included in the same volume. The East and Second families of the Hancock society were located in that section of Pittsfield known as West Pittsfield.

Deming, Nathaniel. "His book of inspired writings. A record of communications from the spiritual world. . . . Given by divine inspiration." Hancock, [Mass.], 1841–45.

Wright, Grove. "Book of inspired writings. A record of communications from the spiritual world. . . . Given by divine inspiration." Hancock, [Mass.], 1841–45 (Andrews Coll.).

"A list of different tribes of Indians & from the world of spirits who came to learn the way of God, of Mother's children on earth. South house. Wisdom's Valley." Watervliet, [N.Y.], 1842.

"A little book containing a short word from Holy Mother Wisdom, concerning the robes & dresses that are prepared for all such as go up to the feast of the Lord, or attend to her holy passover." Hancock, [Mass.], 1842 (Andrews Coll.).

"A record of messages and communications given by divine inspiration in the Second family. City of Peace." Hancock, [Mass.], 1842 (Andrews Coll.).

"Records concerning the finding of Mount Sinai, the Mount of Olives and

Mount Horeb. With the meetings thereon." Hancock, [Mass. ?], 1842.

"Statement of life and sufferings of Jesus Christ. Life and mission of John the Baptist." Harvard, [Mass.], 1842.

"A record kept of the several meetings held upon Mount Sinai by the family orders on days of the feasts." Hancock, [Mass.], 1842–45. (Andrews Coll.).

Deming, William. "A short and interesting account of a beautiful temple, and glorified spirits in heaven. Seen in vision. . . ." Hancock, [Mass.], 1843 (Andrews Coll.).

"Eye-witness account of a mountain meeting of the New Lebanon Shakers in 1843." New Lebanon, [N.Y.], 1843. Typed copy.

"The holy word of the Lord God Almighty, the holy one of Israel to his chosen people throughout Zion's habitations. Given at Wisdom's Valley and written by inspiration at the Holy Mount." New Lebanon, [N.Y.], 1843.

Lyon, J. "A few observations on the reasons why God in manifesting himself to the children of men has made use of signs & figures." Enfield, [N.H.], 1843.

"Inspirational message at City of Peace, written by mortal hand April 9, 1844, through the instrument E. H. [Elvira Hulett]. Also a roll given on Mount Sinai, recorded in 1844 by Inst. Mary Smith." Hancock, [Mass.], 1844 (Andrews Coll.).

"A record of the gifts, messages & communications received thro' divine inspiration from our eternal & heavenly parents & their holy angels. Written by divine inspiration in the First order of the church in the Valley of Wisdom." 10 vols., Watervliet, [N.Y.], 1844.

"Some notices of the meeting of the church and society on the Mount of Olives." Enfield, [Conn.], 1844. Record book of meetings at Enfield, Conn.

"The word of Holy and Eternal Wisdom. Directed to the beloved ministry at Wisdom's Valley, to be dealt with according as their wisdom may direct. Written by inspiration." Watervliet, [N.Y.], 1844 (Andrews Coll.).

"An account of the meetings held in the City of Peace, City of Union, and City of Love, on the 25th of Dec. 1845." Probably Hancock, [Mass.], 1845 (?) (Andrews Coll.).

"Letter from George Washington to Brother Calvin Wells." New Lebanon, "January 6th, 1845."

"Millennial Laws, or gospel statutes and ordinances adapted to the day of Christ's second appearing. Given and established in the church for the protection thereof by Father Joseph Meacham and Mother Lucy Wright. The presiding ministry, and by their successors the ministry and elders. Recorded at New Lebanon Augst 17th. 1821. Revised and re-established by the ministry and elders Octr 1845." New Lebanon, [N.Y.], 1845 (Andrews Coll.). This important "order book," of which there were several copies, varying slightly in content, was revised at New Lebanon as late as 1860. It combined many early orders, or gifts, with material taken from the "Holy laws of Zion."

"A record, of the proceedings of Christmas, in the church, at Holy Ground." Canterbury, [N.H.], December 25, 1845.

Blakeman, Elisha. "A brief account of the society of Germans, called the True Inspirationists, residing seven miles south east of Buffalo . . . from recollections of Peter H. Long and himself after visiting them in the month of August 1846." New Lebanon, [N.Y.], 1846.

"A record of a visit made by the ministry at the City of Peace, to Holy Mount." Hancock, [Mass.], 1849 (Andrews Coll.).

Stewart, Philemon. "Poland book. No. 1 A brief weekly journal." Gloucester, [Me.], 1870 (Andrews Coll.). Reveals the late indifferent attitude of the Shaker ministry towards Stewart's inspirational writings.

"A record of divinely inspired communications and messages." [West family] Hancock, [Mass.], [n.d.] (Andrews Coll.).

"A record of messages and communications given by divine inspiration in the church at Tyringham." [n.p., n.d.]

Shaker hymnals and song books; arranged chronologically

"David Slosson's hymn book." New Lebanon, [N.Y.], 1808 (Andrews Coll.).

"[Song-book of] George DeWitt." New Lebanon, [N.Y.], 1822 (Andrews Coll.).

DeWitt, Henry. "A collection of songs of various kinds: written & pricked for the purpose of retaining them." New Lebanon, [N.Y.], 1837 (Andrews Coll.).

Van Houten, Phebe. "A collection of spiritual hymns, from various authors, selected and transcribed." New Lebanon, [N.Y.], 1837 (Andrews Coll.).

Hazard, Mary. "A collection of songs of various kinds; written & pricked for the purpose of retaining them." New Lebanon, [N.Y.], 1839 (Andrews Coll.).

Rude, Hiram. "A collection of anthems, given by the revelation and gift of God: through the ministration of our blessed Mother Ann. Given in the last part of 1839, the first of 1840." New Lebanon, [N.Y.], 1841 (?) (Andrews Coll.).

Reed, Polly R. "A collection of songs, or, sacred anthems. Mostly given by inspiration. Written for Betsy Bates." New Lebanon, [N.Y.], 1840 (?).

"A little book containing a variety of little songs sung by a little shepherdess who designed one for each of the ministry elders brethern and sisters. Given by inspiration." Watervliet, [N.Y.], 1844.

Youngs, Isaac N. "A collection of spiritual songs: commonly called extra songs; improved in our sacred worship." New Lebanon, [N.Y.], 1845.

Wickersham, George M. "Believers hymns." New Lebanon, [N.Y.], 1846. (Andrews Coll.).

Hazard, Mary. "A collection of extra songs of various kinds written and pricked for the purpose of retaining them." New Lebanon, [N.Y.], 1847 (Andrews Coll.).

Wilson, Hannah. "A collection of gospel anthems. Given to the followers of Christ in his second appearing." New Lebanon, [N.Y.] (?), 1851 (Andrews Coll.).

Hazard, Mary. "A collection of marches

and labouring tunes." New Lebanon, [N.Y.], 1858 (Andrews Coll.).

Printed literature by the United Society of Believers

Bates, Paulina. *The divine book of holy and eternal wisdom, revealing the word of God; out of whose mouth goeth a sharp sword.* . . . 2 vols. in 1. Canterbury, [N.H.], 1849.

Bishop, Rufus (comp.). *Testimonies of the life, character, revelations and doctrines of our ever blessed mother Ann Lee.* . . . Hancock, [Mass.], 1816.

Blakeman, Elisha D. *Youth's guide in Zion and Holy Mother's promise. Given by inspiration at New Lebanon, N.Y., January 5, 1842.* Canterbury, [N.H.], 1842.

Blinn, Henry C. *The manifestation of spiritualism among the Shakers, 1837–1847.* East Canterbury, [N.H.], 1899.

A collection of millennial hymns, adapted to the present order of church. N.H.,[n.d.].

Evans, Frederic W. *Tests of divine inspiration; or the rudimental principles by which true and false revelation, in all eras of the world, can be unerringly discriminated.* . . . New Lebanon, [N.Y.], 1853.

——. *Autobiography of a Shaker, and revelation of the Apocalypse.* Albany, 1869.

——. *Liberalism, spiritualism and Shakerism.* Mt. Lebanon, [N.Y.], 1890 (?).

——. *New England witchcraft and spiritualism.* Mt. Lebanon, [N.Y.], 1879 (?).

——. *The origin and object of spiritualism.* Mt. Lebanon, [N.Y.], [n.d.].

Fraser, Daniel. *The divine procedure in the affairs of men.* Mt. Lebanon, [N.Y.], 1880 (?). Broadside.

The Gospel monitor. A little book of Mother Ann's word to those who are placed as instructors and caretakers of children; written by Mother Lucy Wright, and brought by her to the elders of the first order, on the Holy Mount, March 1, 1841 copied by inspiration at Mother Ann's desire, March 2, 1841. Canterbury, [N.H.], 1843.

Green, Calvin, and Wells, Seth Y. *A summary view of the Millennial Church, or United Society of Believers (commonly called Shakers). Comprising the rise, progress and practical order of the society; together with the general principles of their faith and testimony. Published by order of the ministry, in union with the church.* Albany, 1823.

Holmes, James (comp.). *Collection of anthems revealed by the spirits, 1837–1848.* West Gloucester, [Me.], [n.d.].

Leonard, William. *A discourse on the order and propriety of divine inspiration and revelation, showing the necessity thereof in all ages to know the will of god.* . . . Harvard, [Mass.], 1853.

The manifesto. Shaker periodical published by the United Societies. See vol. XIX, nos. 10–12 (October, 1889, to December, 1889), and vol. XX, no. 1 (January, 1890), for historical account of spiritual gifts received, especially at New Lebanon, from 1837 to 1856.

McNemar, Richard. *The Kentucky revival, or a short history of the late extraordinary outpouring of the spirit of God, in the western states of America, agreeably to scripture-promises, and prophecies concerning the latter day.* . . . Cincinnati, 1807.

——. (pseud. Philos Harmoniae). *A*

selection of hymns and poems; for the use of believers. Collected from sundry authors. Watervliet, [Ohio], 1833.

Meacham, Joseph. *A concise statement of the principles of the only true church, according to the gospel of the present appearance of Christ. As held to and practiced upon by the true followers of the living Saviour, at New Lebanon, etc.* Bennington, [Vt.], 1790.

Millennial praises, containing a collection of gospel hymns, in four parts; adapted to the day of Christ's second appearing. Composed for the use of his people. Hancock, [N.H.], 1813.

Pelham, R. W. *The higher law of spiritual progression.* Shaker tracts no. 2. Albany, 1868.

A sacred repository of anthems and hymns, for devotional worship and praise. Canterbury, [N.H.], 1852. Includes several songs written by inspiration.

Shaker music. Inspirational hymns and melodies illustrative of the resurrection life and testimony of the Shakers. . . . [Albany ?], 1875.

Stewart, Philemon. *A holy, sacred and divine roll and book; from the Lord God of heaven, to the inhabitants of earth: revealed in the United Society at New Lebanon. . . .* In two parts. . . . Canterbury, [N.H.], 1843.

White, Anna, and Taylor, Leila. *Shakerism: its meaning and message; embracing an historical account, statement of belief and spiritual experience of the church from its rise to the present day.* Columbus, [Ohio], 1905.

Young, Isaac N. *A short abridgement of the rules of music. With lessons for exercise, and a few observations; for new beginners.* New Lebanon, [N.Y.], 1843.

Youngs, Benjamin S. *The testimony of Christ's second appearing, containing a general statement of all things pertaining to the faith and practice of the Church of God in this latter-day. . . .* Lebanon, [Ohio], 1808. The so-called Shaker Bible, Youngs being the chief author.

II. Other Sources

Expositions by outside observers

Baker, Arthur. *Shakers and Shakerism.* (New moral world series no. 2.) London, 1896.

Bates, Barnabus [Benjamin Silliman ?]. *Peculiarities of the Shakers, described in a series of letters from Lebanon Springs, in the year 1832, containing an account of the origin, worship, and doctrines, of the Shakers' Society. By a visiter.* New York, 1832. Especially letter ix, "The peculiar manner of worship among the Shakers."

Brown, Thomas. *An account of the people called Shakers: their faith, doctrines, and practice, exemplified in the life, conversations, and experience of the author during the time he belonged to the society. To which is affixed a history of their rise and progress to the present day.* Troy, [N.Y.], 1812. Includes an account of Shaker dances and speaking in unknown tongues, by an apostate of the society.

Dixon, William Hepworth. *New America.* Philadelphia, 1867. Especially chaps. xlvi and xlvii, "Resurrection order" and "Spiritual cycles."

Elkins, Hervey. *Fifteen years in the senior order of Shakers: a narration of facts concerning that singular people.* Hanover, [N.H.], 1853.

Extract from an unpublished manuscript on Shaker history (by an eyewitness), giving an accurate description of their songs, dances, marches, visions, visits to the spirit land, etc. Boston, 1850.

Haskett, William J. *Shakerism unmasked, or the history of the Shakers. . . .* Pittsfield, [Mass.], 1828.

Hinds, William Alfred. *American Communities.* Oneida, [N.Y.], 1878. Shaker worship, p. 110f.

Howells, William Dean. "A Shaker village," *Atlantic Monthly,* XXXVII (June, 1876), 699–710.

———. *The undiscovered country.* Boston: Houghton, Mifflin and Co., 1880. The basis of Shaker faith is described as "uninterrupted revelation." Conditions were favorable during the period of Shaker manifestations, Howells wrote, for making this world approximate the imagined life of the world of spirits.

Lamson, David R. *Two years' experience among the Shakers: being a description of the manners and customs of that people, the nature and policy of their government. . . .* West Boylston, [Mass.]: Published by the author, 1848. Account by an apostate of the mountain meetings, rituals, ceremonials, and gifts at the Hancock community.

MacLean, J. P. *Shakers of Ohio. Fugitive papers concerning the Shakers of Ohio, with unpublished manuscripts.* Columbus, [Ohio], 1907. Especially pp. 388–415: "Spiritualism among the Shakers of Union Village, Ohio."

Nordhoff, Charles. *The communistic societies of the United States. . . .* New York, 1875.

Noyes, John Humphrey. *History of American socialisms.* Philadelphia, 1870. Especially chap. xliii, "The spiritualist communities," and chap. xlv, "The Shakers." Includes an account of Shaker dancing.

Poole, Cyrus O. *Spiritualism as organized by the Shakers.* New Lebanon, [N.Y.], 1887. Address before the Brooklyn Progressive Conference, October, 1887; reprinted from the *Banner of Light.*

Prince, Walter F. "The Shakers and psychical research," *Journal of the American Society for Psychical Research,* XII, no.1 (January, 1918).

A return of departed spirits of the highest characters of distinction as well as the indiscriminate of all nations, into the bodies of the "Shakers," or, "United Society of Believers in the second advent of the Messiah." By an associate of said society. Philadelphia, 1843.

A revelation of the extraordinary visitation of departed spirits of distinguished men and women of all nations, and their manifestation through the living bodies of the "Shakers." By a guest of the "community" near Watervliet, N.Y., Philadelphia, 1869.

Sears, Clara Endicott. *Gleanings from old Shaker journals. . . .* Boston, 1916. Especially chap. xxiv: "The wave of mystic symbolism."

Accounts of other forms of religious art: automatic writing; spirit drawings

Mercer, Henry C. *The survival of the mediaeval art of illuminative writing among*

Pennsylvania Germans. (Contributions to American history, by the Bucks County Historical Society, no. 2.) Philadelphia, 1897.

Muhl, Anita. *Automatic writing.* Dresden and Leipzig, 1930.

Podmore, Frank. *Modern spiritualism. A history and a criticism.* 2 vols. London, 1902.

Shambaugh, Bertha M. H. *Amana that was and Amana that is.* Iowa City, 1932. An interesting treatment of the inner forces of inspiration in a German-American communal order known as the Community of True Inspiration.

Stoudt, John Joseph. *Consider the lilies how they grow. An interpretation of the symbolism of Pennsylvania German art.* Allentown, [Pa.], 1937. A discussion of a religious art with roots in Christian mystical tradition.

Wilkinson, W. M. *Spirit drawings: a personal narrative.* London, 1858. Mrs. Wilkinson and her son, aged 12, drew automatically, sometimes buildings or scenes but more commonly flowers "of no known order." It will be noted that none of the Shaker drawings were credited to children.

Index

Italicized page numbers refer to illustrations.

Visions of the Heavenly Sphere

was composed, printed, and bound by Kingsport
Press, Inc., Kingsport, Tennessee.
The types are Bank Script and Baskerville, and
the paper is Mohawk Superfine.
The color plates were printed by The Meriden
Gravure Company, Meriden, Connecticut.
Design is by Edward G. Foss.